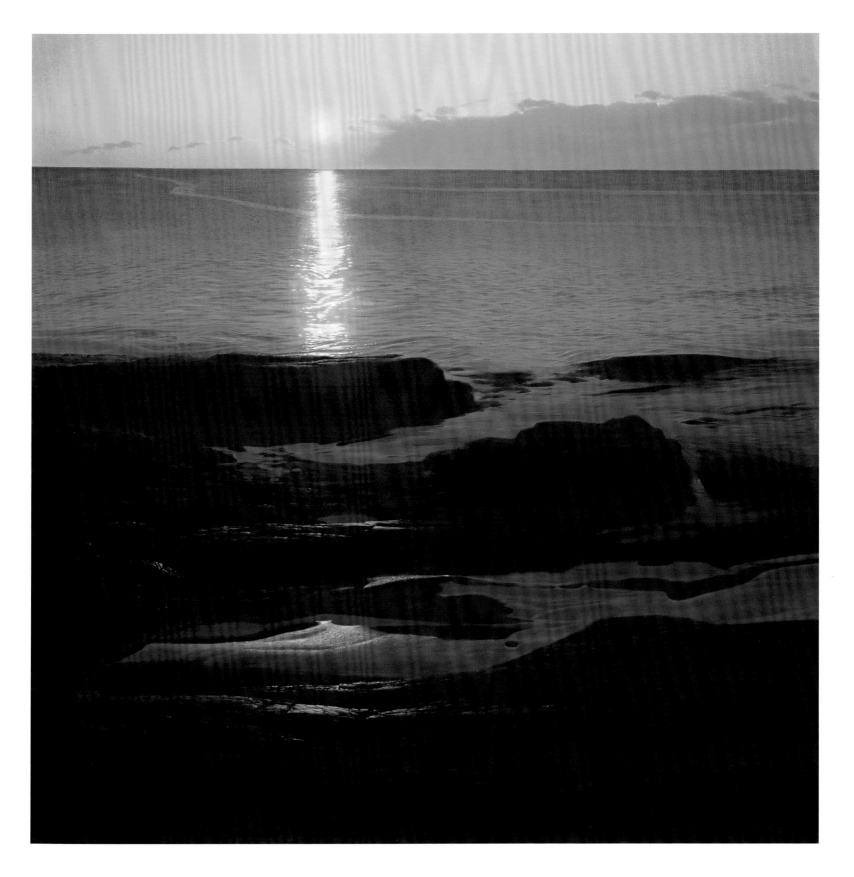

SUNRISE, INDIAN POINT, ca. 1989

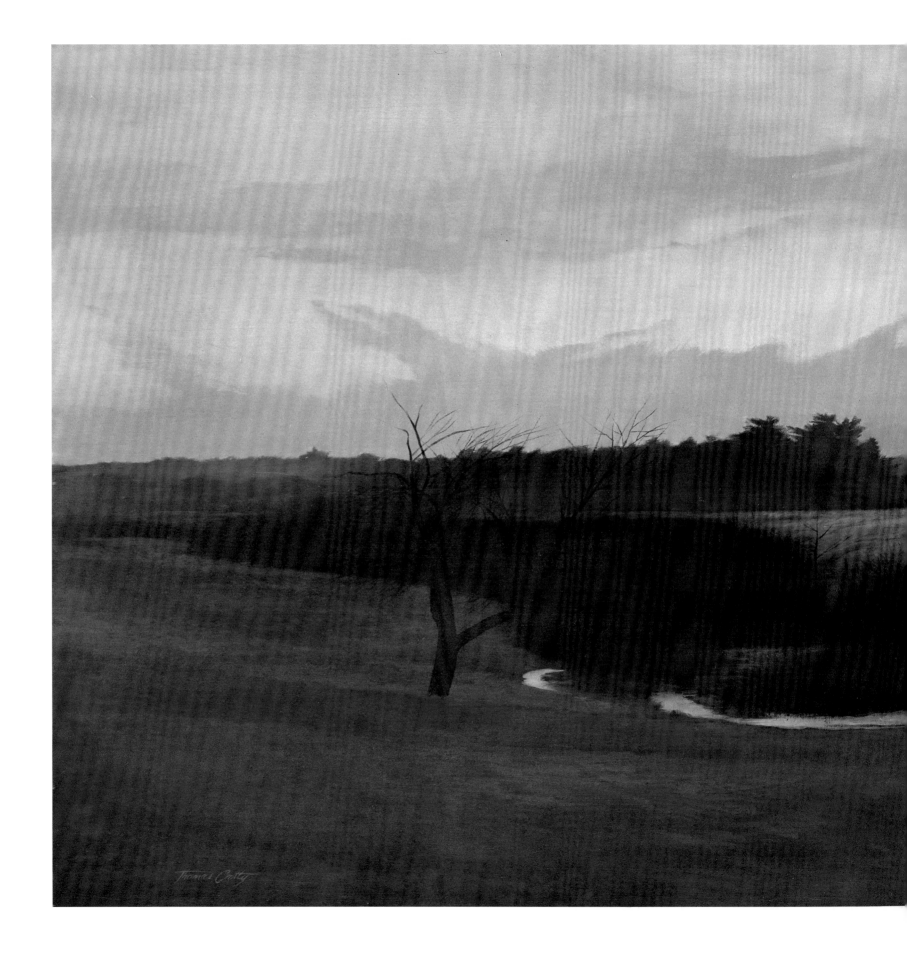

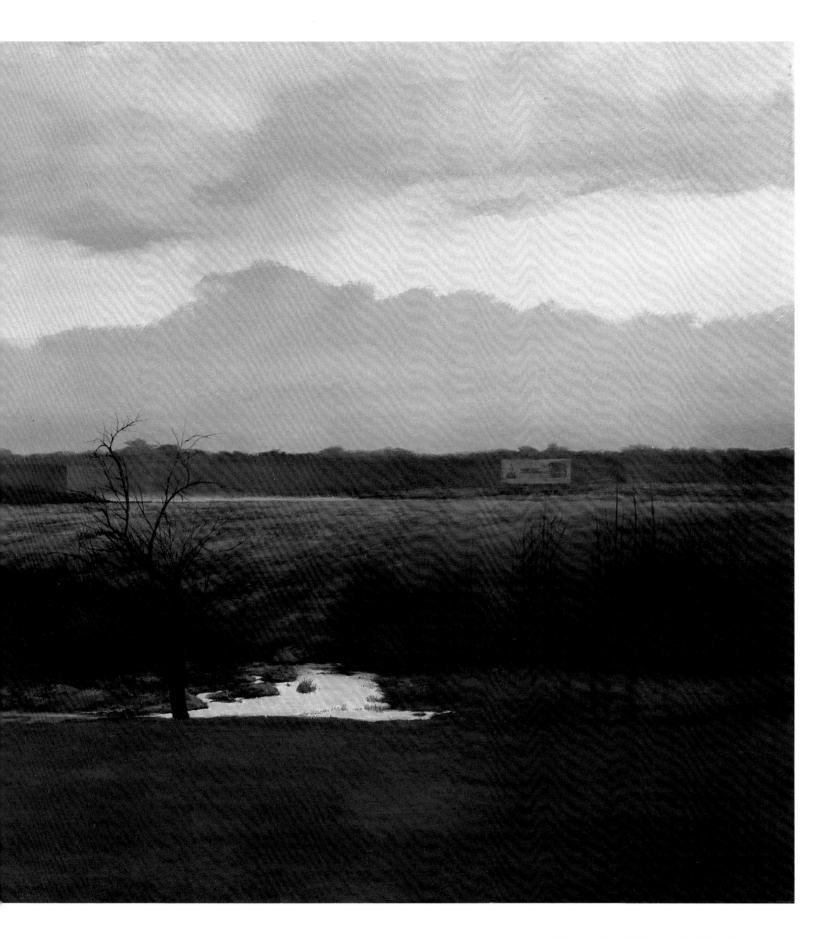

FROST GULLY WITH BILLBOARDS, ca. 1980

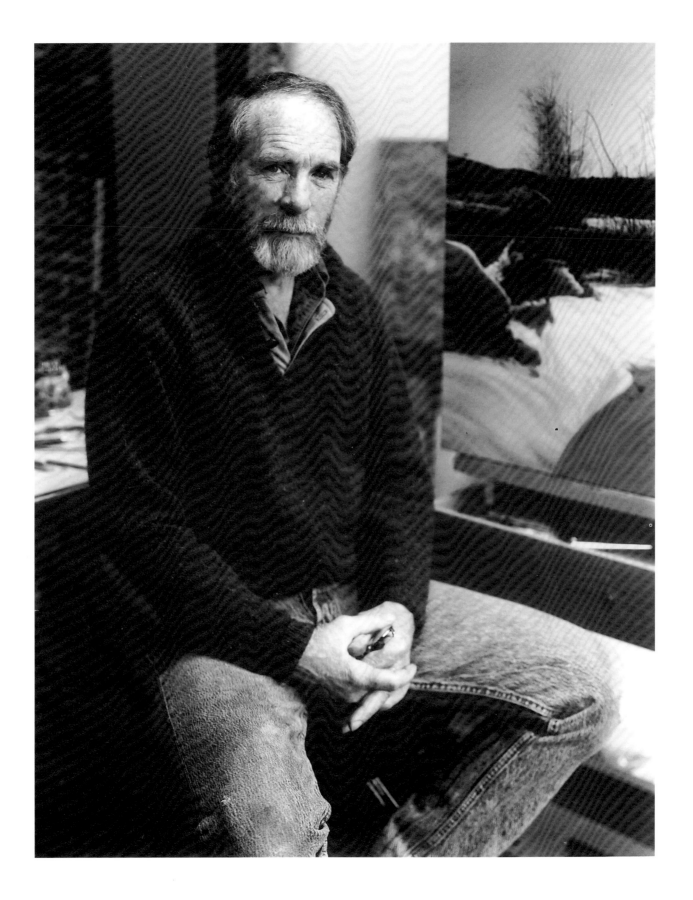

THOMAS CROTTY

A SOLITUDE OF SPACE

DOWN EAST BOOKS, CAMDEN, MAINE, 2003

IN ASSOCIATION WITH THE

PORTLAND MUSEUM OF ART

SEVEN CONGRESS SQUARE, PORTLAND, MAINE

Published by
Down East Books
Camden, ME 04843
Book Orders: 800-685-7962
www.downeastbooks.com

Published in association with the exhibition
A Solitude of Space: The Paintings of Thomas Crotty
Portland Museum of Art
September 25, 2003–January 4, 2004
Curated by Daniel E. O'Leary and Lorena A. Coffin

Produced by
Chameleon Books, Inc.
31 Smith Road
Chesterfield, MA 01012

Copy Editor: Jamie Nan Thaman
Production Assistant: K. C. Scott

Printed in China

ISBN: 0-89272-628-8

Library of Congress Control Number: 2003104555

Frontispiece:
Thomas Crotty in his studio, Freeport, Maine, 1994

PREFACE
by Daniel E. O'Leary

A SOLITUDE OF SPACE:
THE PAINTINGS OF THOMAS CROTTY
by Francine Koslow Miller

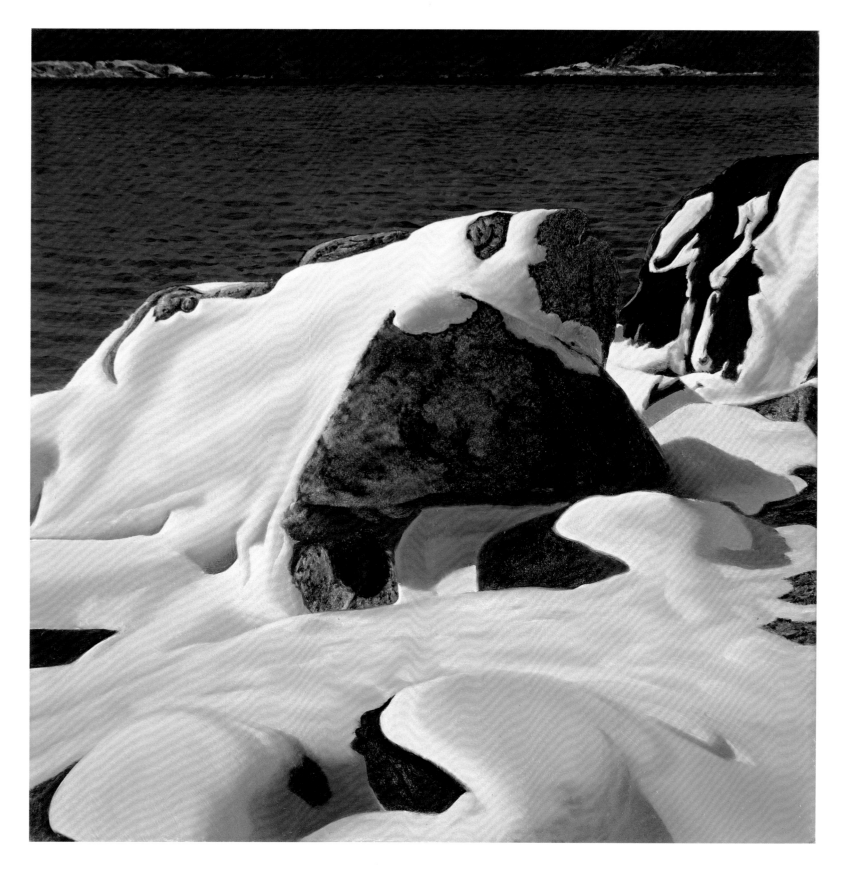

SAGADAHOC BAY, ca. 1996

PREFACE

One of America's defining strengths arises from its extraordinary expansiveness, and from the refuge and inspiration these spaces give to individualism.

In the nineteenth century, the poems of Emily Dickinson—secretive and self-sufficient in her private universe at Amherst—and the meditations of Henry David Thoreau—immersed in the seclusion of Walden Pond—record the triumphs of two aloof and intense spirits. In the visual arts, the solitude that Winslow Homer sought at Prout's Neck and in unspoiled stretches of the Adirondacks provided the catalyst for some of America's first truly American masterpieces.

In the following century, the restless journeys of Marsden Hartley indicate that his search for a defining place went unrequited until the final stages of his life, when he returned to his native Maine. In contrast, Georgia O'Keeffe firmly established her haven at Ghost Ranch, where a primacy of place enhanced her vision for decades.

The career of Thomas Crotty dramatically affirms these same priorities. As a painter, he has claimed and exploited a sovereignty of place that has defined his work for four decades. Along the coast of Maine, from Freeport to Stonington, Thomas Crotty has kept faith with a world of natural beauty that is reserved and profound.

The sixty works in the exhibition *A Solitude of Space: The Paintings of Thomas Crotty* reveal the devotion of an artist who has entrusted his career to the fundamental principle of the miracle of Maine light. For Crotty, perhaps more than for any other artist of his era, that light ebbs and flows with extraordinary grace, and is transformed not only by each season but by every hour.

The Portland Museum of Art takes great pleasure in sharing these images of Maine with thousands of visitors who, along with the artist, revere the landscape of this inspiring region. We thank the many collectors who have parted with their cherished examples of Thomas Crotty's art. For them, almost without exception, they are not only images of nature but icons of place.

Daniel E. O'Leary
Director
Portland Museum of Art

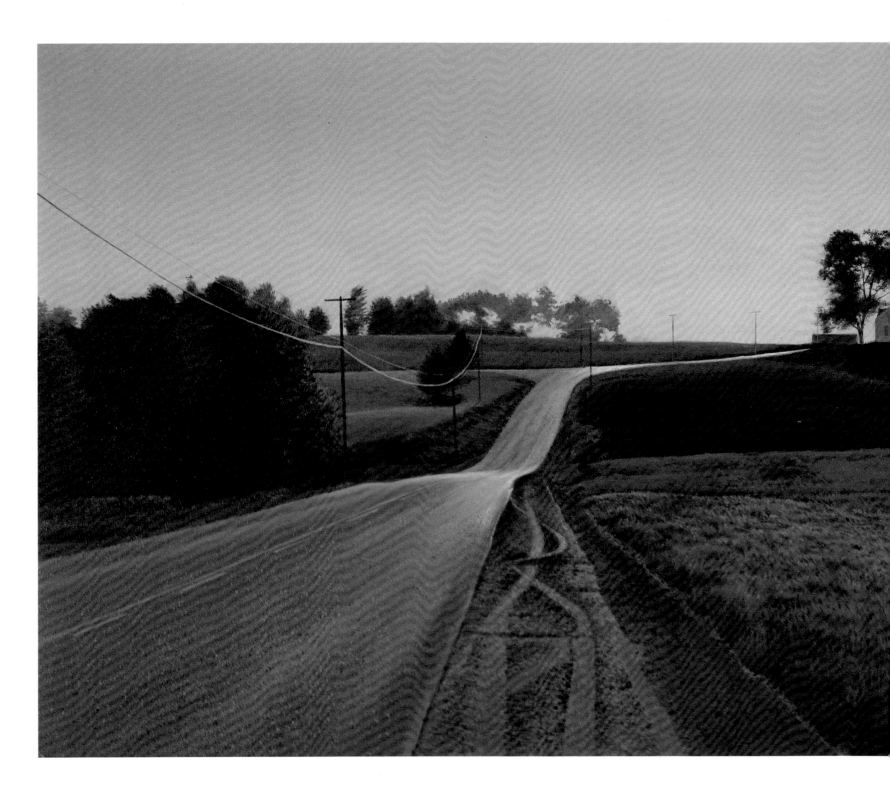

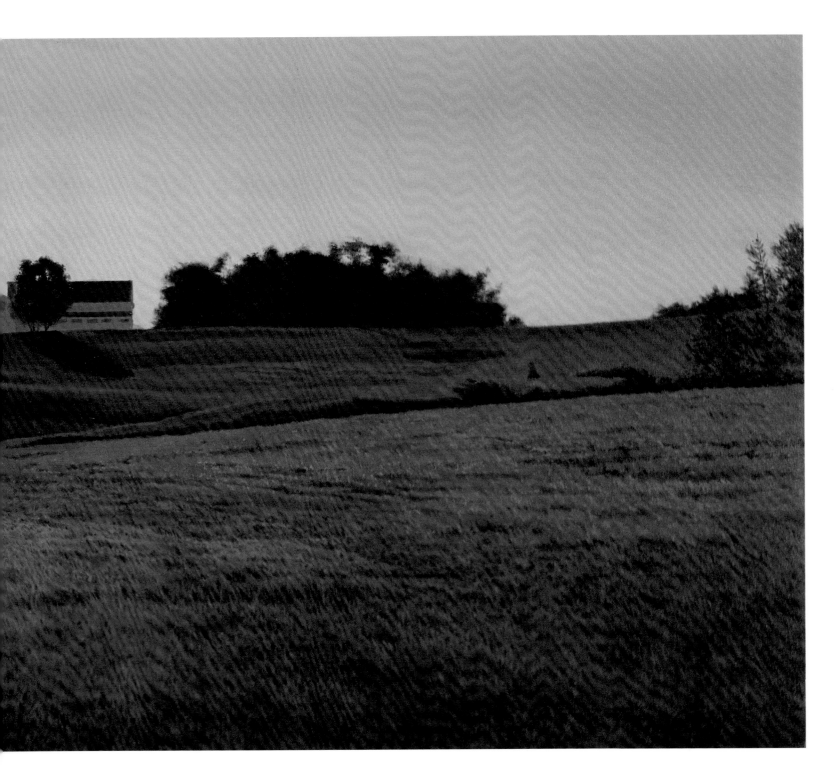

DYER ROAD, POWNAL, ca. 2000 11

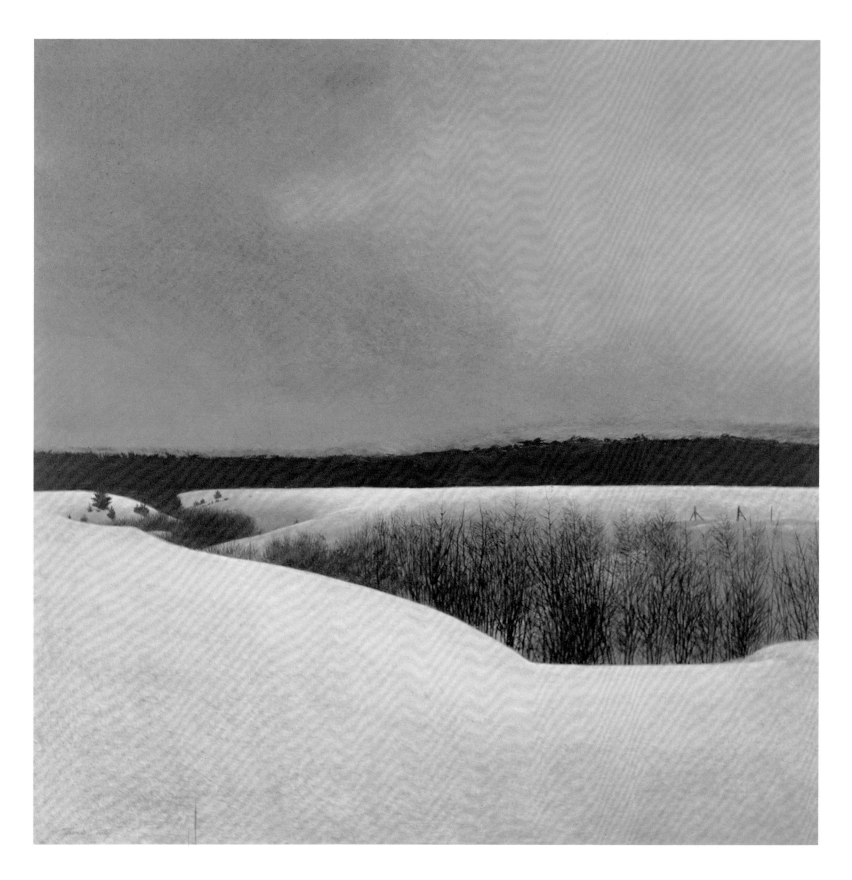

BREAKING, ca. 1975

A SOLITUDE OF SPACE:
THE PAINTINGS OF
THOMAS CROTTY

But alone in distant woods or fields, in unpretending
sprout-lands or pastures tracked by rabbits, even in a
bleak and, to most, cheerless day, like this, when a vil-
lager would be thinking of his inn, I come to myself,
I once more feel myself grandly related, and that cold
and solitude are friends of mine...I thus dispose of the
superfluous and see things as they are, grand and
beautiful.

—HENRY DAVID THOREAU, *Journal*, January 7, 1857

Like the famed nineteenth-century nature philosopher
Henry David Thoreau, Thomas Crotty is friend to cold and
solitude. Choosing Maine's sparsely settled open places—
hidden shorelines, rock-strewn pastures, snow-covered
ledges—Crotty mingles the physical and spiritual qualities of
his adopted home in realist paintings that convey his deep
respect for the silence of nature. His tranquil and meditative
paintings often capture the twilight world before dawn or at
dusk, when the light is at its most rich, peaceful and still. He
manipulates light to create vast, contemplative scenes out of
the quiet prose of his life in Maine. His seemingly strict real-
ism encompasses a clear concern for abstract elements of
composition that underlie the cleanly delineated forms and
spaces of his work.

Crotty's art springs from his deep attachment to Maine's
landscape and particularly to Maine in winter. He is, in his
own words, a decidedly "off-season artist," enthralled with the
colors and shapes of a snow-covered land:

The middle of Maine along the coast is the exact cen-
ter of the world I have explored. From Freeport to
Stonington is the heart of my world. I have lived in

Thomas Crotty with his painting *Crescent Beach,* acrylic on
masonite, 1970

the same house for almost forty years. That's about as native as you can get. My work is very much about this area and it is even more about my own evolution in trying to understand the mysterious and sublime wonders of this small part of our precious world.[1]

While an admirer of the great American nineteenth-century masters, whose sublime landscapes often focused on the grandiose and primordial beauty of nature, Crotty has chosen to live and operate within a special world defined by specific boundaries As he matured and developed into a romantic realist landscape painter, the character and shape of his Maine environment strengthened and sustained him. Crotty's feeling of awe at the extreme beauty of nature is awakened in the airy fields behind his Freeport home, in the shiny rocks and tides of an abandoned local beach, or on a lonely local intersection.

Crotty is a nonconformist of exceptional talent, with a well-seasoned mistrust for much of today's critical theory. Since 1966 he has run his own gallery—the Frost Gully Gallery—and promoted the careers of a formidable group of regional painters. He writes trenchant art criticism for local newspapers and regularly argues his well-formulated views on art and politics.

A born outdoorsman and adventurer, Crotty is an experienced sailor who designed his own racing/cruising thirty-five-foot sailboat. He has derived almost as much joy from his many years of sailing as he has from his paintings.

TURKEY COVE, ca. 1998

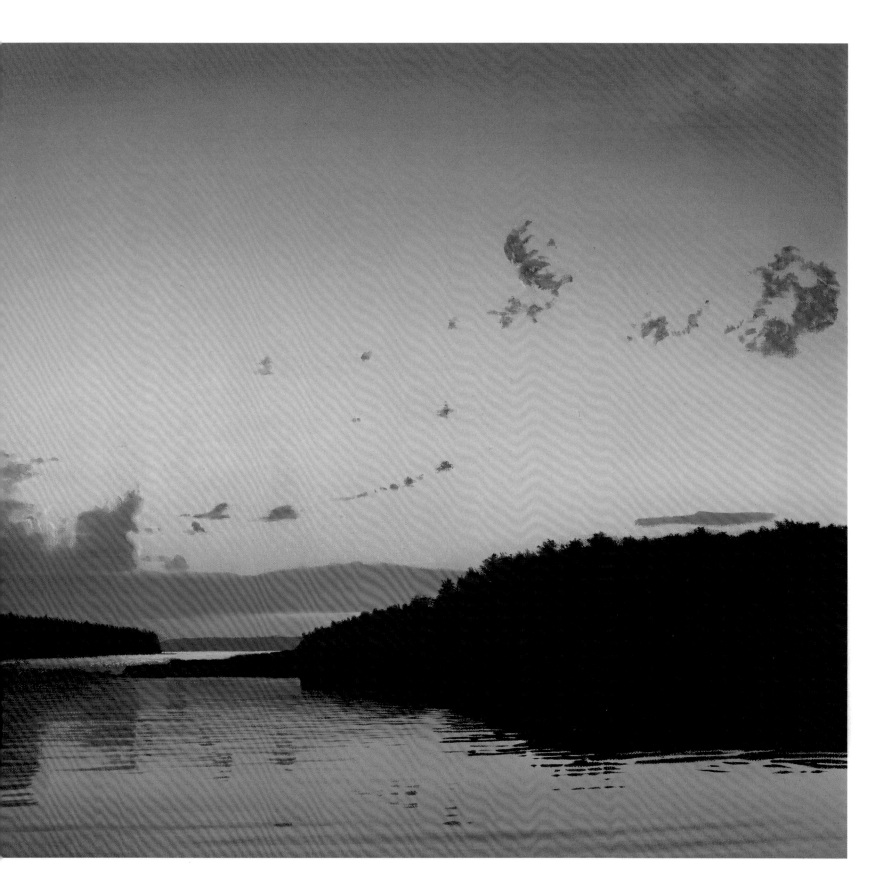

RED RIGHT, ca. 1993

CHILDHOOD

Reflecting on the forces that shaped his art and character, Crotty stresses the great importance of his early childhood and upbringing. Born November 30, 1934, in Boston, Thomas Robert Crotty was the eldest of five children born to Donald Edward and Wanda Johnson Crotty. Suffering the full effects of the Great Depression, Crotty's father, a journalist and entrepreneur, moved the family several times to find work. In 1936, Donald Crotty briefly held a position as an editor for a small newspaper in Charlottetown on Prince Edward Island, Canada. The family soon relocated to the coastal town of Summerside, where Donald Crotty tried his hand at running a restaurant. Crotty recollects:

> My father designed and built a semicircular wood
> restaurant himself. Unfortunately there was little need
> for a new restaurant, round or otherwise, so he tore
> the restaurant down and used the lumber to build the
> house that we lived in.[2]

From earliest childhood, Crotty turned to the sea for solace and excitement. He remembers going out with a local fisherman on the Northumberland Straits. "That opened up a whole world for me even as a five-year-old."[3] It was during those years in the Canadian Maritimes that he began his lifelong infatuation with the rugged North Atlantic Ocean, making numerous drawings of the boats he watched passing by.

Because his father's shifting employment kept the family constantly on the move, Crotty's mother was often consumed

Thomas Crotty posing for a holiday photograph, 1938

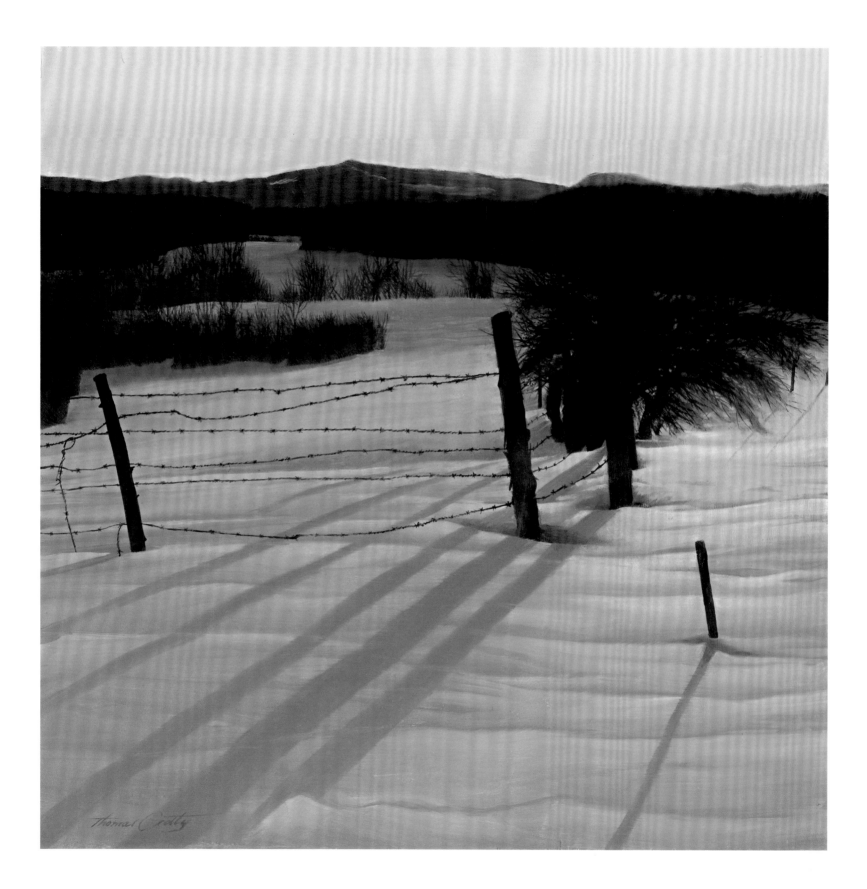

DUSK, NEW VINEYARD, ca. 1996

with resettling and caring for her husband and five young children. This dynamic encouraged Crotty to be independent and self-sufficient early on. Crotty fondly remembers the family's old farmhouse in rural Cartierville—with its expansive backyard woods, ponds, and streams—where they lived after his father took a position as a journalist in Montreal. "I spent most of my leisure time by myself in the woods, letting my imagination take me on endless fantastic journeys. I was a loner, even when I was that young."[4] He had discovered first the sea and then the woods, two subjects that would engage him throughout his career.

Crotty recalls another example of his early independence and determination:

> While we were living in Cartierville, I would walk a mile, get on a bus for a five-mile ride to a train for a ten-mile ride into Montreal where I attended first grade in a parochial school. I spent most of my time drawing sailboats and Spitfires instead of participating in class activities. The headmaster, a resourceful and astute soul, offered me a deal: pay attention in class and I will give you all the pencils and paper you want—and you can draw during the last period in my outer office. This positive treatment would have a huge effect on me for years and was a big boost to my thinking of myself as an artist.[5]

For reasons never explained or questioned, Crotty was soon sent to live for a year with his father's devout Catholic stepmother in Moncton, New Brunswick. Forced into strict austerity ("We didn't even have a radio then," he recalls[6]), Crotty remembers finding pleasure in the natural beauty of this region on the Petitcodiac River. The great tides of the Bay of Fundy are funneled into the Petitcodiac River in southeastern New Brunswick, and this huge body of water rushes up the river to Moncton. "There's a ten- to forty-foot solid wall of water there," Crotty muses, "and the result is one of the

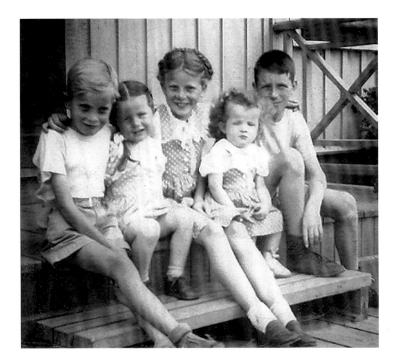

The Crotty children in 1945 (from left to right: Donald, Wanda, Margaret, Ingrid and Thomas)

largest tidal bores in the world."[7] When the rest of Crotty's family joined him in New Brunswick, they all moved to a wartime housing development in nearby Lakeburn. Crotty remembers the public school there fondly:

> It was a small school with students in all twelve grades. There were instances of more than one grade in a room. The days were long, from eight in the morning to four in the afternoon. But, there was very little homework—mostly reading assignments. There was a lot of interaction between students and between students and teachers.[8]

In addition, both penmanship and drawing were important components of all subjects—even math. It was during the years in Lakeburn that Crotty was able to attend camp over several summers. By the time he was ten or eleven, he had developed a serious interest in drawing, which found expression in pencil renderings he would make of his friends

and fellow campers. He gave all of them away to his subjects.

For three years, Crotty's father left his family behind to take prestigious jobs—first in Montreal and then in New York City as an editor for United Press. It was at this point in 1946 that Donald Crotty faced a crucial decision. After much searching, he could not find a place near the city for a family of seven to live, so he decided to leave a position with a promising future to be reunited with his family. When he returned to Lakeburn, he started a local Maritimes news service. The business became a successful corporation, but before long, some directors and stockholders gained control of the company and took over. Depressed and deeply in debt, he returned to Boston in 1949 with his wife, two sons, and eldest daughter, leaving his two younger daughters in Moncton with their aunts. It would be more than ten years before these girls would reestablish contact with the family, and they would never see their father again.

The Crottys, crowded into a one-room apartment near Beacon Hill, suffered another severe blow in 1952 when Crotty's frail younger brother, Donald Jr., died from injuries sustained during a fall from a new bicycle. "My father decided to head to Boston because of his hope that Donald Jr. might receive treatment at the famous Boston Children's Hospital for his congenital heart problem."[9] Crotty and his father shared a particular kind of pain in Donald Jr.'s death. Young Donald had come to Crotty one day with an announcement of a contest in the *Boston Globe* to color a drawing of the famous painting of Washington crossing the Delaware. Crotty helped Donald with a drawing that won first prize—a bicycle. Since Donald was too weak to ride the bike, his father took him for a ride, and they had a spill. Young Donald suffered a concussion, lapsed into a coma, and never recovered. "Young Donald's death destroyed my father, and severe depression combined with alcohol, cigarettes, and terrible

"Joe Lee" sailboats on the Charles River, Boston, 1952

nutritional habits led to his tragic death at age forty-four in 1954."[10] Crotty remembers being continually amazed at the complete, unquestioning devotion and love his mother exhibited for his father through those years.

Crotty found it difficult to concentrate in school. He dropped out of both Boston Technical High School and Boston English High School, finding various jobs as a cab driver, foreign car mechanic, car salesman, and clerk at Jordan Marsh department store before eventually receiving his high school equivalency after a year at Newman Preparatory School.

Literally and figuratively, Crotty managed to stay afloat during his turbulent adolescent and young adult years due in large part to the paternal guidance of Joseph Lee II, who had served on the Boston School Committee for twenty-five years, including several stints as chairman during the tumultuous 1960s and 1970s. In 1937, Lee had started a small public-sailing program to offer Boston youngsters a chance to learn to sail. Crotty explains:

> Joe Lee built three sixteen-foot double-ended sailboats
> and taught street kids how to sail. That's how I started
> sailing. By the time I came along, they had Joe Lee
> Boats—beautiful sailboats with colored sails. I used to
> love to sail.[11]

Having befriended Lee's son at a local playground on Myrtle Street on Beacon Hill, Crotty was treated like family in Lee's stable home. He spent long winter weekends skating with the family and took summer cruises out to Gloucester or Scituate on Lee's thirty-foot sailboat. Through Lee, Crotty was introduced to the Boston Park Yacht Club, then located at a dock on Storrow Drive on the Charles River. It was there that Crotty learned to sail and race.

Joe Lee was a true visionary who started Boston Community Boating. Long before there was Outward Bound, Lee was

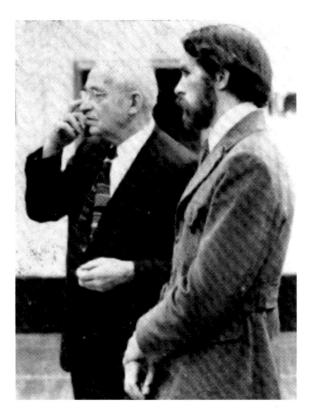

Joseph Lee (left) with Crotty at the opening of *Thomas Crotty: Acrylics, Watercolors, Drawings* at The Guild of Boston Artists, 1969

22 PORT CLYDE, ca. 1990

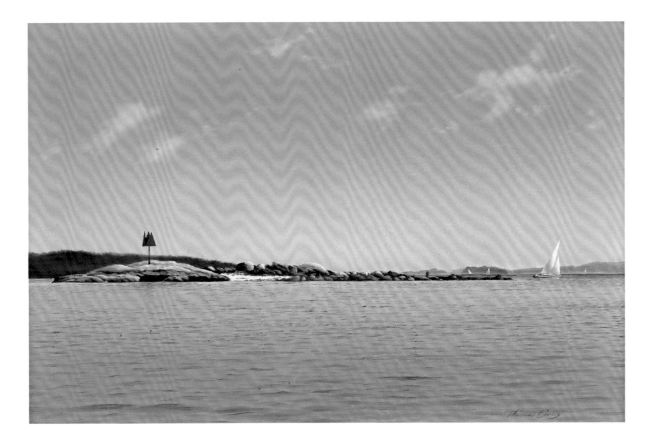

taking instructors and sailing youngsters from the Charles River area out for entire weekends, summer after summer, on his thirty-foot English sailing lifeboat. "We cooked on Sterno, used a bucket for a head, and slept eight to ten people under a tarpaulin that covered the entire boat at night. We cruised all over Mass Bay from Gloucester to Plymouth. We learned a lot more than sailing skills."[12] This culminated in Crotty winning the annual Boston Park Yacht Club Regatta in 1952 and being hired as a sailing instructor at the yacht club.

Despite his family's tragedies and his struggles in school, Crotty considers himself to have been extremely lucky as a youth because of Lee's friendship and guidance. Lee, who became a father figure to Crotty, posed for a picture with the artist many years later at his first solo exhibition in 1969 (p. 21).

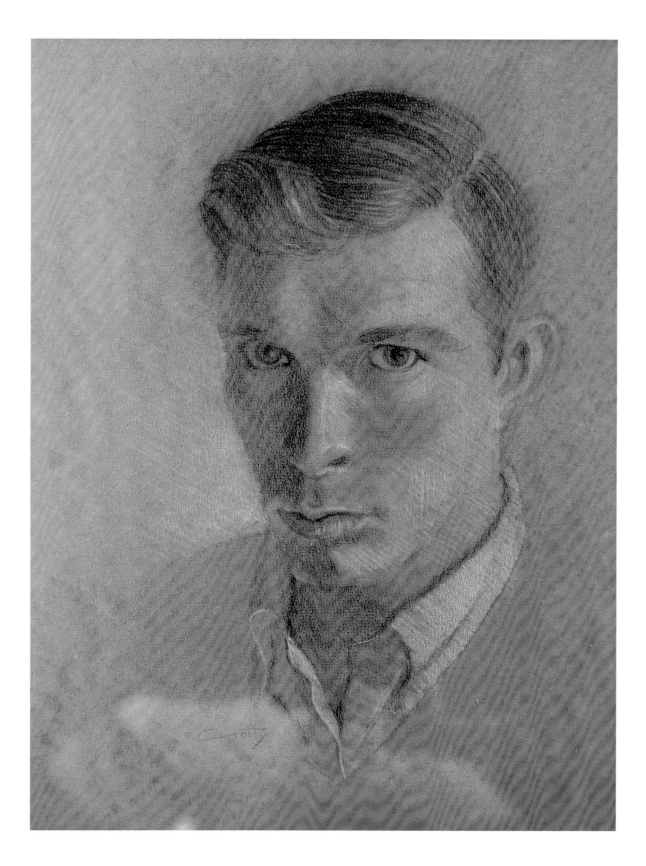

24 SELF-PORTRAIT, ca. 1965

ARTISTIC TRAINING

At age twenty-two, Crotty decided to pursue a career as an artist. While he was serving in the National Guard, he was accepted to the Massachusetts College of Art for the fall of 1958. Soon, however, he found himself deeply disappointed with the artistic atmosphere there. Even then, Crotty was looking for solid drawing and technical instruction, and he discovered that at the Massachusetts College of Art the emphasis was on abstract painting and an expressionist free-form method of instruction that paid little attention to the

basics and fundamentals that Crotty was seeking. He explains, "I was not growing. I suspect that my deep interest in craft and realism contrasted too sharply with the popular academic views prevalent at the time."[13] Boston art historian John Stomberg confirms Crotty's assessment about the lack of support for realist painting in the 1950s:

> [I]n 1950, realism was seen by a vociferous and power-ful minority as a singular, monotypic burden to advancing art. These attacks came most notably from partisan supporters of Abstract Expressionism, who defined their art in part as an opposition to realist art. This bias led to a generation of artists, critics, art his-torians, and curators that largely ignored, or on occa-sion openly castigated, artists who persisted in depict-ing the visible world.[14]

While studying at the Massachusetts College of Art, Crotty met Carolyn (Bunty) Wallace—a student at Fisher Junior College whose family was from Bridgton, Maine; they married in December 1958. To help pay his way through school and support his wife, Crotty, who had been driving a cab, decided to begin work as a lobsterman in Cohasset, Massachusetts.

> At first I thought that I could put myself through Mass Art through lobstering part-time in the summer and fall. But, it was a bad idea—there are no lobsters in the summer. That's when they shed and hide. In the late summer and fall, they appear. So, one day dur-ing my junior year in October I was out on my lobster boat and I realized that this really gorgeous world was there. For me, at least at that time, it was not in a classroom at Mass Art.[15]

Crotty's intense involvement with the sea helped him to reestablish his nature-oriented view of the world—a view that was lost in the academic environs of college. He dropped out of art school in 1960 and began work in Cohasset as a full-time lobsterman for the next two years. "First I had a row-boat and a few pots. The next winter, I bought an eighteen-

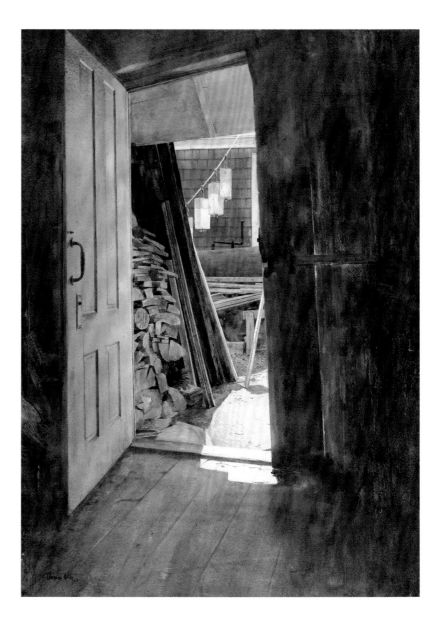

RALPH'S, ca. 1965

APPLE TREE IN WINTER, ca. 1969

foot Novi skiff, and eventually a forty-foot Novi lobster boat. I gained confidence and control of my life out there," he asserts.[16] **Ralph's** (p. 26)—one of his first acclaimed watercolors,[17] painted from memory and drawings made on site—represents the small South Shore rustic shop where Crotty used to build his lobster traps. Through an open door, we see a woodpile and Crotty's yellow and white buoys hanging diagonally from ropes in the sun. Featuring an early favored palette of yellows, browns, and grays, this composition already demonstrates Crotty's remarkable ability to use lighting for dramatic effect.

In 1962, the needs of his growing family (sons Donald and David were born in March 1960 and 1961) grounded Crotty. Realizing that he really wanted to be an artist, he looked for less seasonal employment away from the ocean. He soon found it at Rust Craft Greeting Card Company, then based in Dedham. Rust Craft, a company begun in 1906 by Fred Winslow Rust, was a leader in many areas of holiday greeting-card production, including design and use of unusual surfaces, colors, and sentiments; it employed many young graduates from the nearby Massachusetts College of Art and the School of the Museum of Fine Arts. At Rust Craft, Crotty learned the fundamentals of drawing and how to use and mix watercolors, inks, and casein paint. Crotty specialized in realistic floral still-lifes and claims, "I learned more in six months at Rust Craft than in all my years at Mass College of Art. I learned how to handle a large range of art materials, and how to set a goal and achieve it."[18]

Greeting cards designed by Thomas Crotty

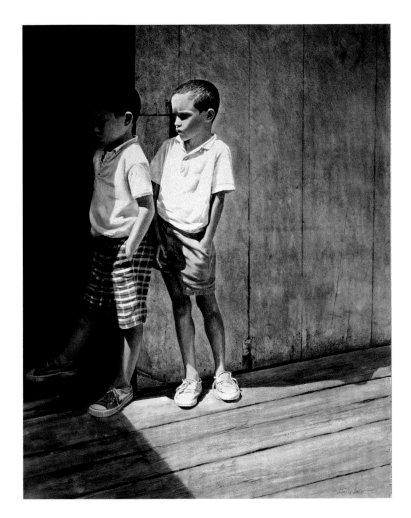

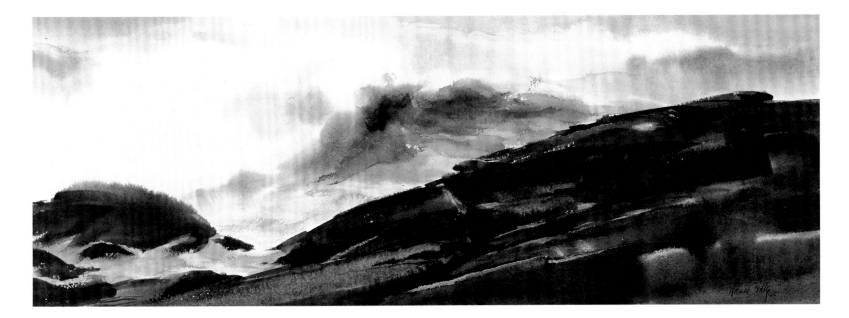

(Above) DONALD AND DAVID, 1969

NEWSPAPERS, 1969

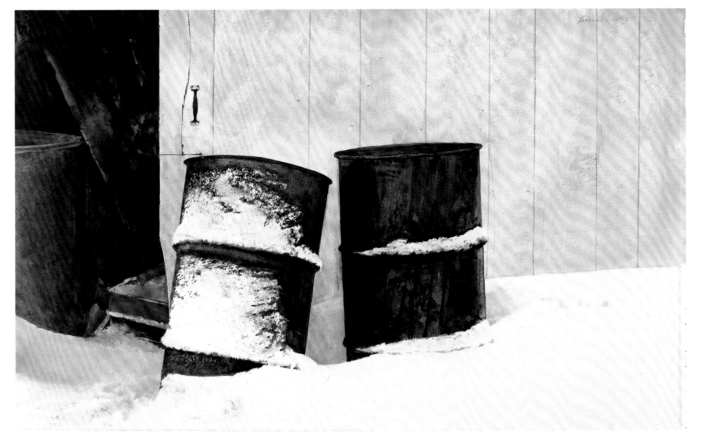

(Above) SELF-PORTRAIT, ca. 1967 BARRELS BY THE BARN, 1967 31

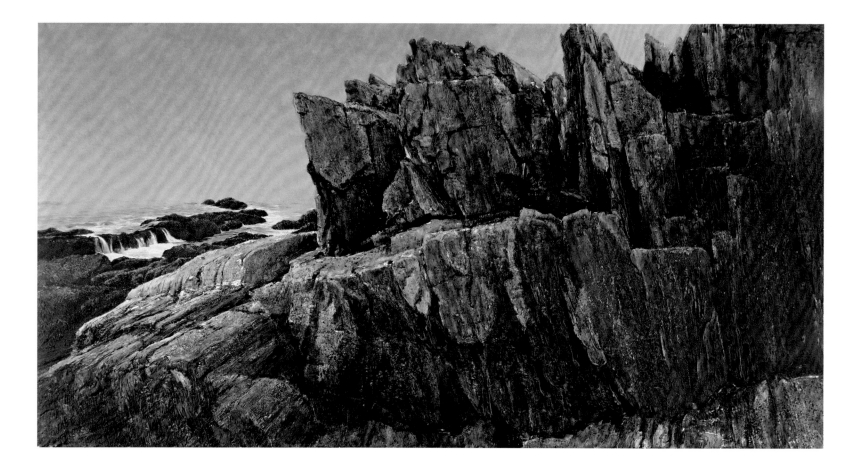

THE STEPS, 1967

MAINE: ARTISTIC AWAKENING

As Boston became more crowded and expensive in the early 1960s, Crotty and his wife began to look for an affordable place to raise their children. In 1963, the Crottys moved to Windham, Maine, to live with Bunty's parents. Crotty found work as a designer and paste-up artist for Ad-Ventures Advertising in Portland. In the evenings, he designed greeting cards for Gibson Greeting Cards of Cincinnati and painted landscapes in watercolor and acrylic for himself.

Lured by the beauty of the rural countryside and the idyllic rocky coast, Crotty moved his family to Cape Elizabeth in 1964. There, he began painting in earnest and produced what he considered to be his first good work. Although he continued his freelance greeting card work until 1971, Crotty gave up his day job in 1966 and began showing his work in major exhibitions around New England. He received awards from the American Watercolor Society, the Boston Watercolor Society, and Jordan Marsh's annual exhibitions of contemporary New England artists. A key work from Crotty's earlier period is **Meridian** (p. 35), a precisely rendered watercolor demonstrating his interest in regional subjects and mastery of form, color, and light. This white, brown, and black-toned composition depicts a profile view of a handsome brown farm horse in a paddock before a pristine New England barn. A remarkably detailed rendition of the paddock's stone wall crops the view of the horse and dominates the foreground.

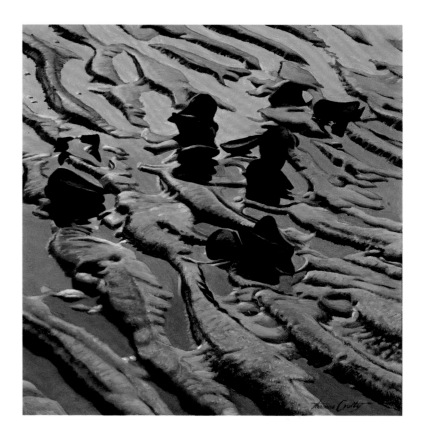

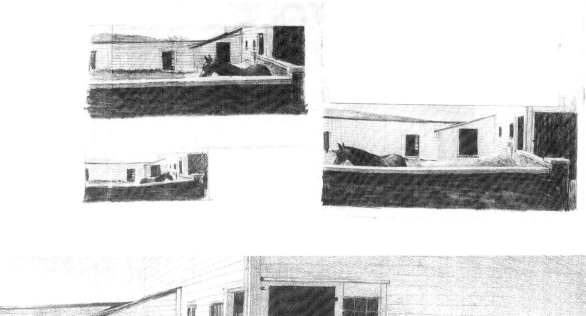

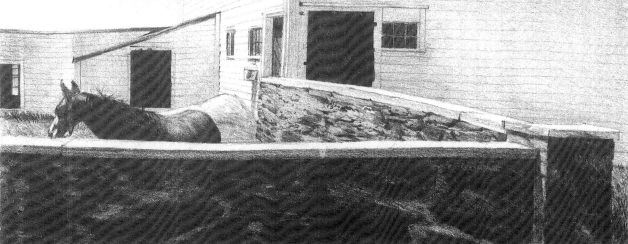

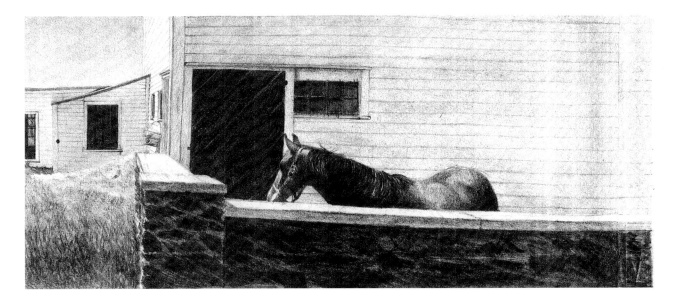

Pencil studies showing the artist's development of his composition for the watercolor *Meridian*

Several delicate pencil studies for *Meridian* indicate how closely Crotty observed this horse through the different positions, textures, and angles he explored before arriving at the final composition. Featured in 1967 at the 79th Boston Watercolor Society exhibition, *Meridian* was described as a "showstopper" by Carol Le Brun, an art critic for the *Boston Herald*. "The texture, colors and attention to details are remarkable for the medium and show an important talent," she wrote.[19]

In the mid-1960s, Crotty began his pictorial romance with the rocky shoreline of Maine. **The Steps** (p. 32), painted in acrylic, dramatizes the precipitous rocks and pounding Atlantic Ocean. Crotty exaggerates the texture and jaggedness of the sharply focused foreground ledges and juxtaposes them with the breaking waves in the distance.

The Crotty family welcomed daughter Johanna, born in March 1965, and the next year settled in an old farmhouse on Route l in Freeport. Built around 1840, the picturesque farmhouse and barn were set on five acres of rural land adjacent

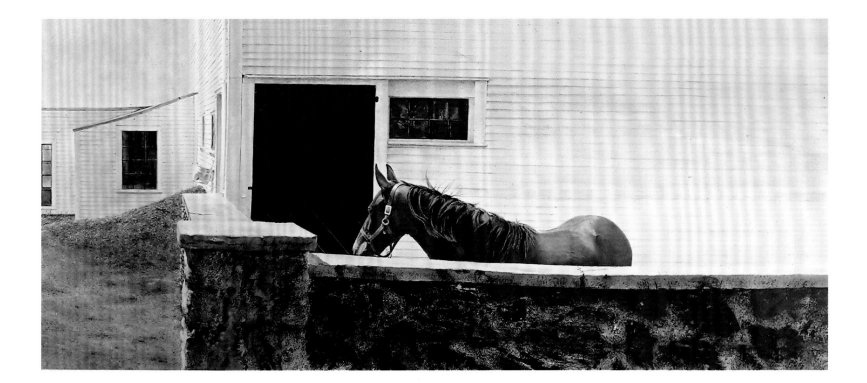

to Frost Gully Brook. Crotty found the subjects that would consume him for the next four decades in his own backyard, in the neighborhood arbors and fields, and in the ledges of local shorelines.

When he first arrived in Maine, Crotty discovered that the state had no serious year-round gallery showing the work of contemporary Maine artists. In 1966, he and Bunty opened the Frost Gully Gallery in the barn adjacent to their farmhouse. After a few seasons, his stable of artists included Leonard Baskin, Thomas Cornell, George Curtis, David Driskell, Stephen Etnier, Beverly Hallam (his former teacher at the Massachusetts College of Art), DeWitt Hardy, Dahlov Ipcar, Bernard Langlais, John Laurent, Leo Meissner, Robert Eric Moore, Laurence Sisson, Warren Spaulding, Ed Stearly, William Thon, and Valerie Zint. Crotty soon discovered that he enjoyed the company of these artists and that he shared Etnier's and Sisson's preference for unspoiled and solitary seascapes. The Frost Gully openings became local social events, and articles describing the Crottys' preview sherry parties regularly appeared in the society section of the *Maine Times*. More significantly, Edgar Allen Beem—longtime art critic for the *Maine Times*—later acknowledged that Crotty "showed some of the best art being made in Maine at that time."[20]

During his early years in Freeport, Crotty's artistic production centered on his domestic life. In 1967, second daughter Melissa was born, and the artist's family and house cats became the subjects of a number of intimate watercolor and acrylic paintings. **Donald** (p. 38), an acrylic in warm brown tones, features Crotty's reticent, introspective eldest child. Here, the seven-year-old namesake of Crotty's late father and brother is portrayed in a black wool stocking cap, blue jeans, and hooded winter coat, seated on the wooden steps of the barn. A dramatic light from outside the frame bathes the boy in the afternoon sun and highlights Donald's reluctance to

The Curtis Farm in Freeport, Maine, purchased by the Crottys in 1966

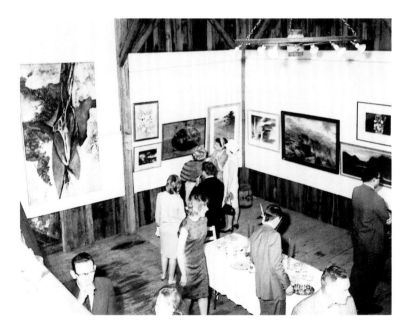

An opening at the Frost Gully Gallery in Freeport, Maine, ca. 1967

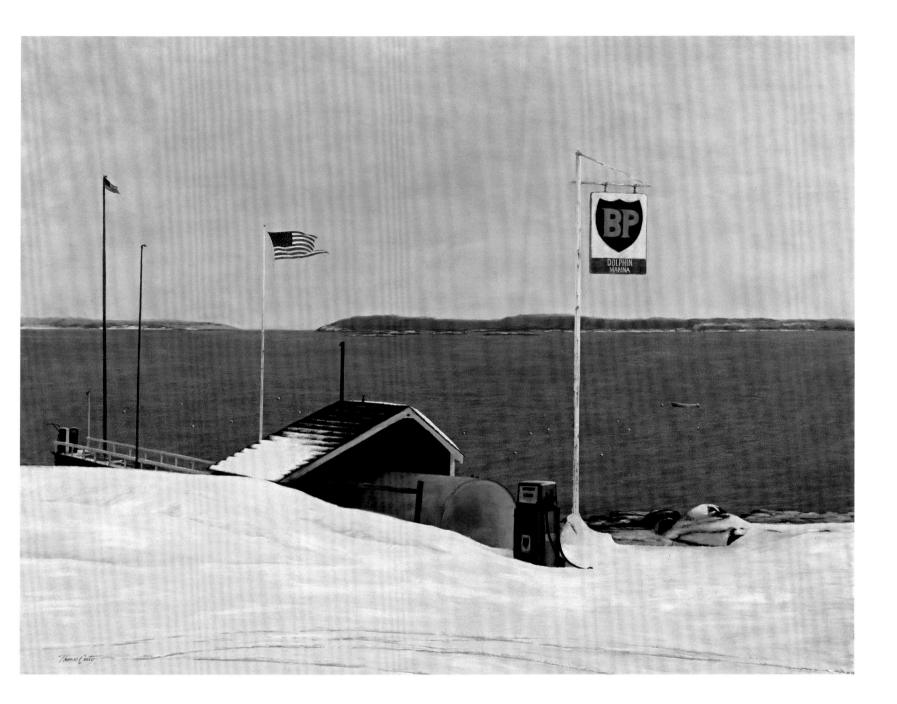

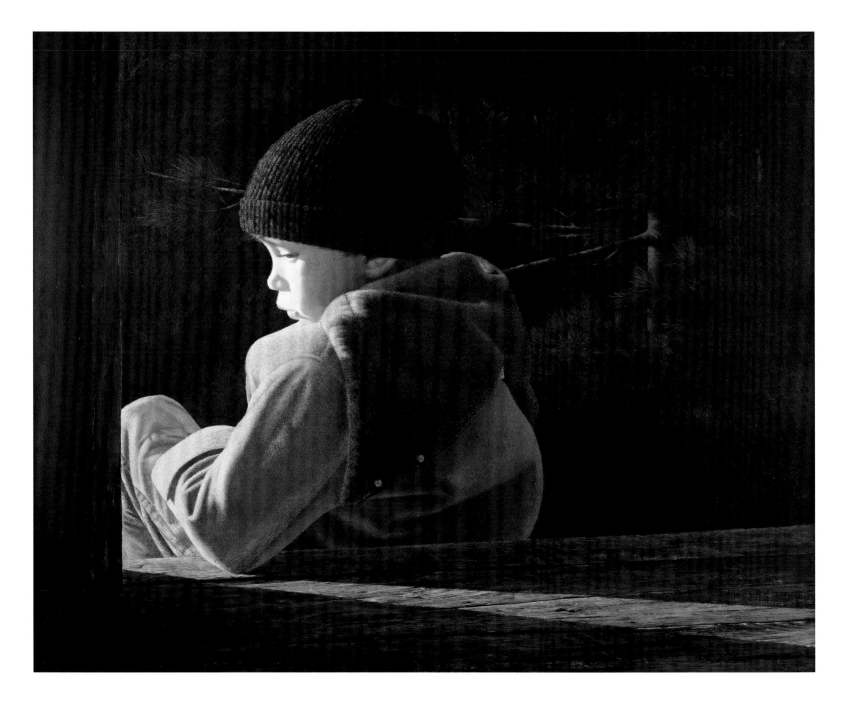

38 DONALD, 1969

pose for his father. After its inclusion in the pivotal *Four Maine Artists* exhibition at the William A. Farnsworth Art Museum in Rockland, *Donald* was added to the museum collection in August 1969. Crotty recalls, "Andrew Wyeth's wife, Betsy, had taken a strong interest in the work and asked the Rockland Museum to put it on hold for her. But the museum decided to purchase it for its own collection."[21] Later that year, *Donald* was reproduced on the cover of the catalogue to Crotty's first one-person show of acrylics, watercolors, and drawings at the Guild of Boston Artists on Newbury Street, Boston; the show later traveled to Westbrook Junior College in Portland, Maine. With these successes, Crotty made the decision to work hard to establish himself as a New England artist.[22] He began to receive critical and public attention as an artist who painted in a realist manner akin to Andrew Wyeth.

Wyeth was Crotty's first major artistic hero. In 1963, Crotty had been very inspired by a large exhibition of Wyeth's dry-brush and pencil drawings at the Fogg Art Museum. Crotty, who admired the simplicity and lack of pretension in Wyeth's work, explains, "Wyeth was an important person for me because in the 1950s and 1960s, the world of contemporary realism was a very dull place. The only thing that was really accessible to me was Wyeth."[23] Wyeth, whose family had first begun summering in Port Clyde in the 1920s, had also strengthened Crotty's desire to come to Maine.

As a young painter intrigued by the thought of personal contact with a great artist, Crotty brought along some of his own art when he first sought Wyeth out at a favorite Cushing event:

> We met in 1965. I gathered up my watercolor *Ralph's* and another watercolor of two dories in a field, and made my way to the Cushing Fair. And there he was. I approached Wyeth, and he was kind. He invited me back to his house and offered me concrete and constructive comments on my work.[24]

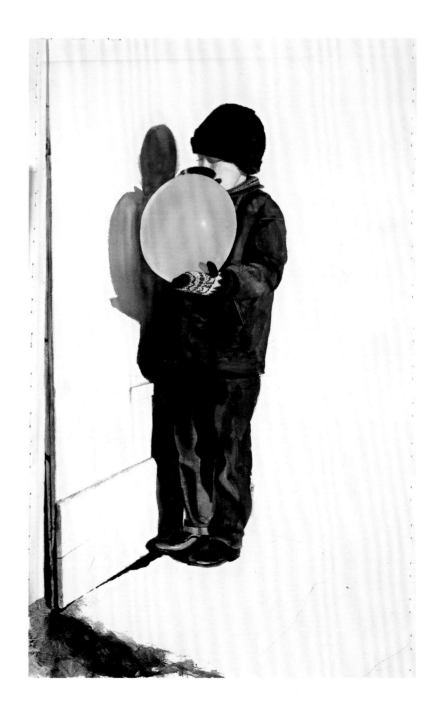

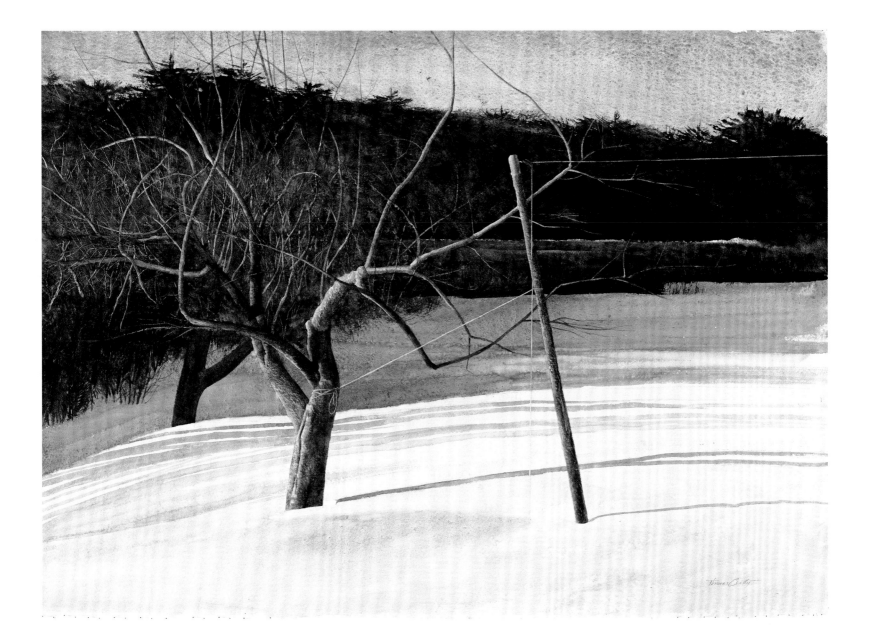

40 WINTER ORCHARD, ca. 1982

Crotty visited Wyeth once or twice a year until about 1972, and he would generally bring along a painting or two for Wyeth to critique. Crotty so appreciated Wyeth's guidance and the example set by his haunting views of the Maine landscape that he gave him one of his watercolors. **Chaney's**, a rust-toned image of an empty bucket turned on its side, also features a weathered ship's knee and a broken fence. Crotty was delighted that Wyeth accepted his token of affection, and he still cherishes a souvenir that Wyeth gave him during one of their visits together at Cushing: a cropped section of a panel painted by Wyeth—all abstract splotches and drips.

The romantic realism of Crotty's striking watercolor **October Snow** (p. 42) reflects the positive influence that Wyeth had on his work. The painting depicts a rare early snowfall that occurred on October 23, 1969. Crotty's source

for this remarkably accurate depiction of dying green and brown leaves of a lone chestnut tree touched with snow near Frost Gully was a photograph taken early that October morning with Crotty's first professional 35mm camera, an Asahi Pentax. "That was when I started using photographs to work from," he recalls.[25] The elegantly cropped watercolor image is given a mysterious aura by the shadow of an unseen ladder on its trunk. The exquisite detailing on the bark of the sturdy tree is balanced by the delicacy and fragility of the thin branches and leaves; the sudden change of seasons results in a study of nature in transition. Interestingly enough, Wyeth had also been moved to do two paintings that day documenting the snowstorm in Cushing. One was of a spruce bough heavy with snow and transformed by winter (p. 43). Crotty recalls:

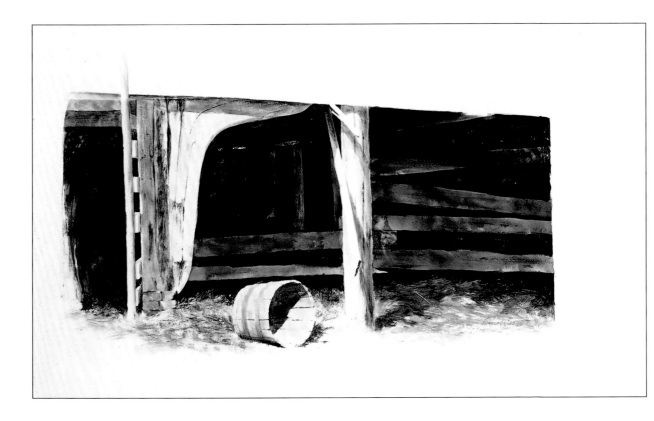

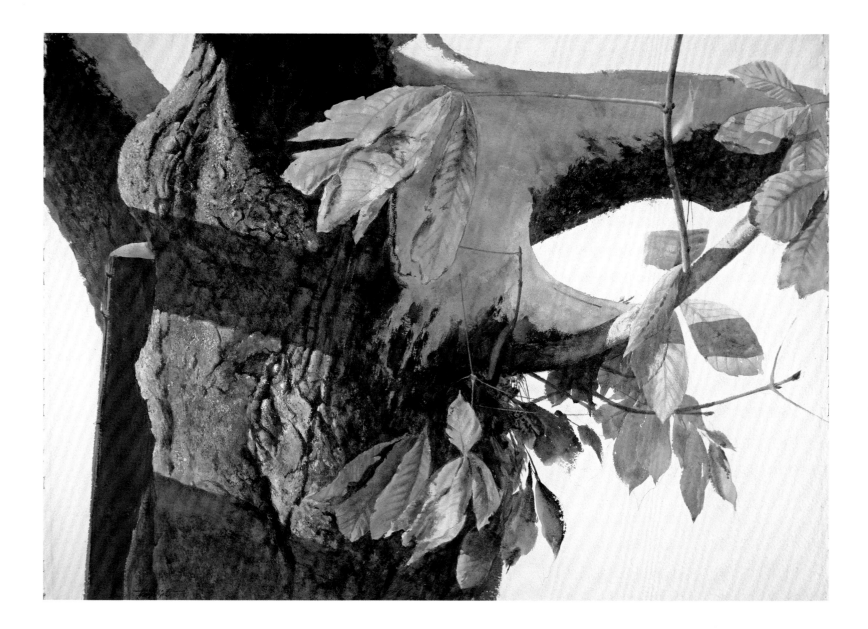

OCTOBER SNOW, 1970

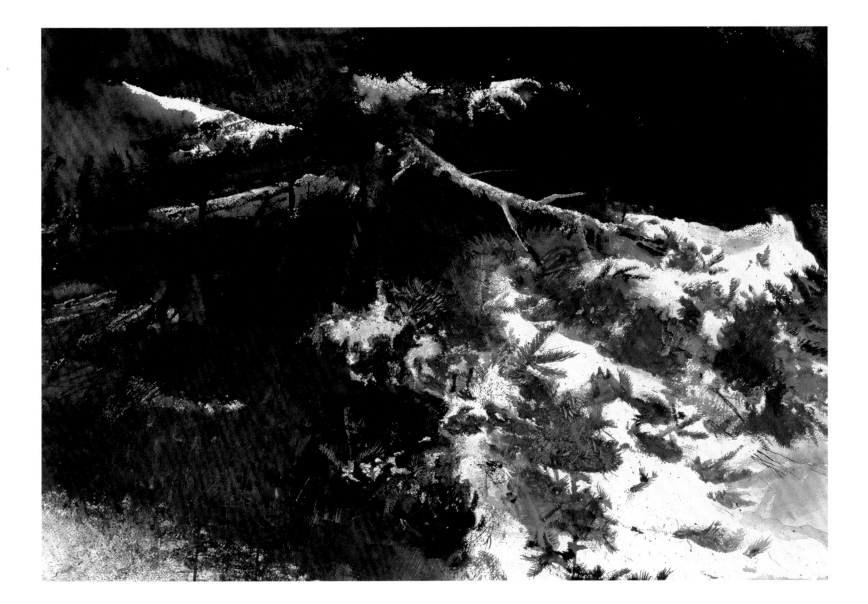

Andrew Wyeth, SPRUCE BOUGH, 1969

That day I had a date with Andrew Wyeth. At 3:00 P.M., he was sitting in his driveway, finishing a watercolor. He had done a painting that day of the Olsen farm in the morning and had painted the watercolor of snow on the boughs of a spruce tree that afternoon.[26]

In both Wyeth's and Crotty's watercolors of that October day, there is a contagious quality of quietude and a keen sense of rural nostalgia.

In June 1972, the Crottys divorced, with the four children remaining at the farm in Freeport with their father. Although there were many upsetting domestic changes, 1973 proved to be a remarkable year professionally for Crotty. He moved the gallery to Portland and became active in local art politics. Later he would become the founder and first president of the Portland Society of Galleries and Museums, and a member of the architectural planning committee and fellow of the Portland Museum of Art. He had a successful one-person show at the Farnsworth Art Museum, which traveled to John Whitney Payson's Hobe Sound Galleries in Florida and to the Van Vechten Gallery of Fine Arts at Fisk University in Nashville, Tennessee. The show earned Crotty considerable praise, as indicated by the response of David Driskell, the chairman of the Fisk University Department of Art:

> There are a few people among us who without reservation deserve to be called fine artists of the first order. Tom Crotty is one such person whose genius in the craftsmanship of painting is readily seen. He possesses the rare qualities of the artist-naturalist who is very much in tune with nature's way of making. He is in the same breath a man who has the inner vision of the poet. His canvases sing aloud the beauty of the land and often feature those elements and objects that bring us in contact with the natural world.[27]

Through these shows and through his own gallery sales, Crotty began to receive significant recognition for the stunning realism of his paintings and for his skillful portrayal of

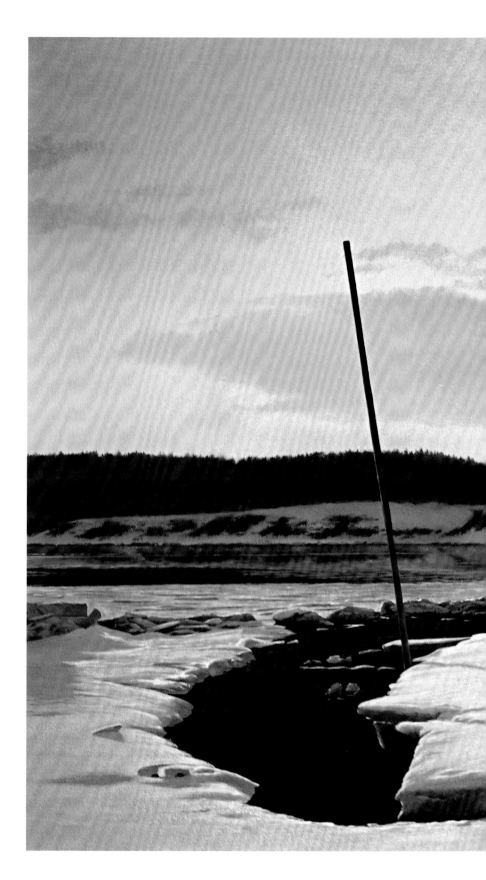

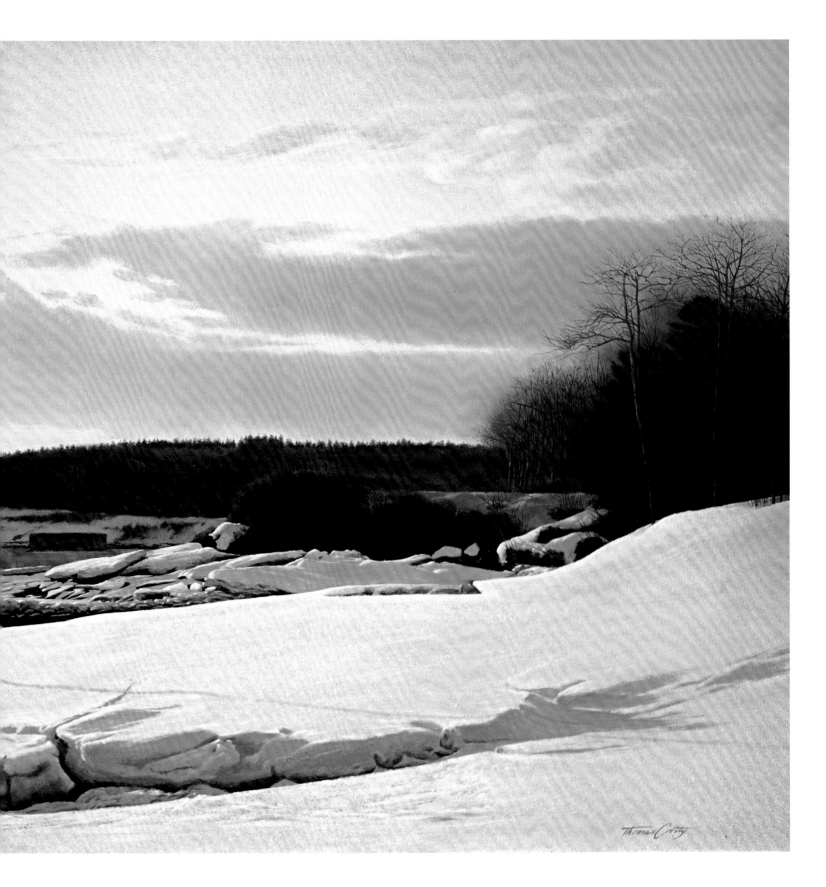

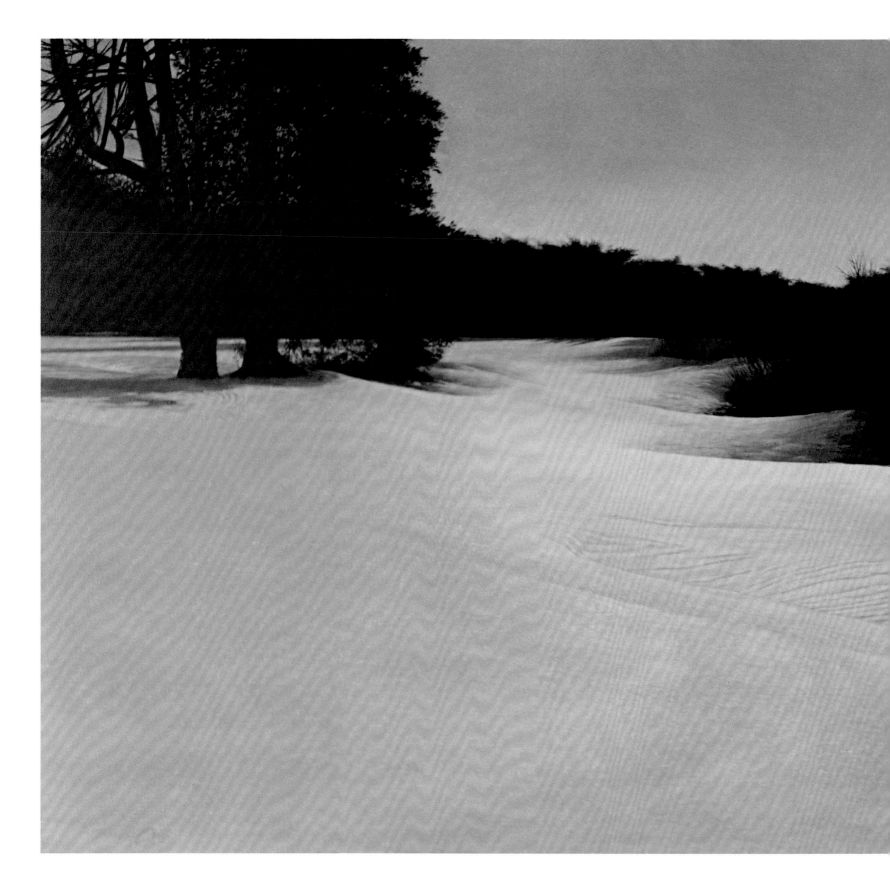

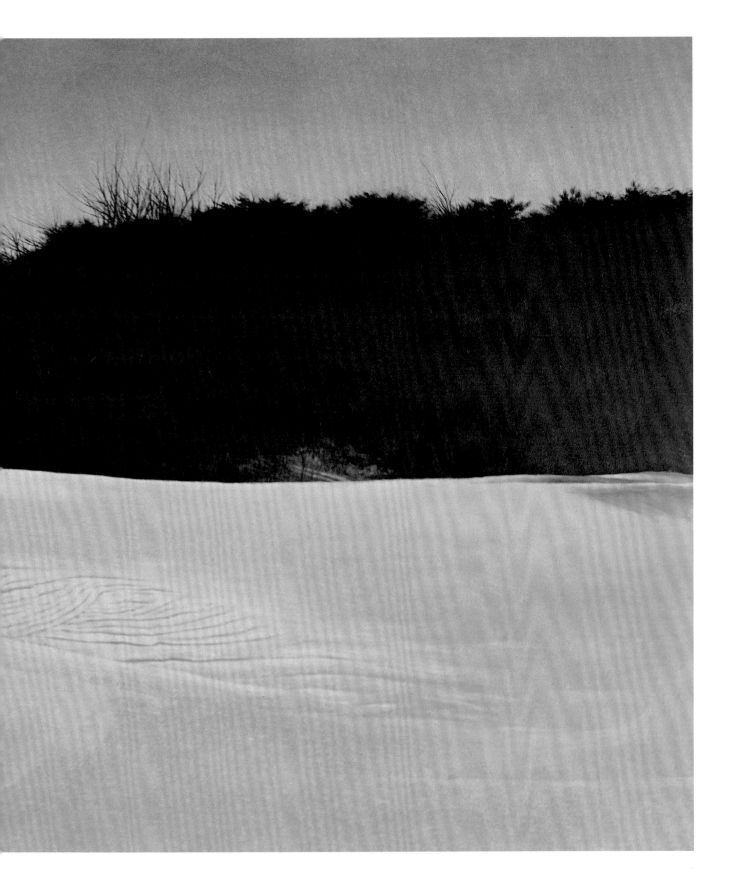

BACKYARD WINTER SOUTH, ca. 1988 47

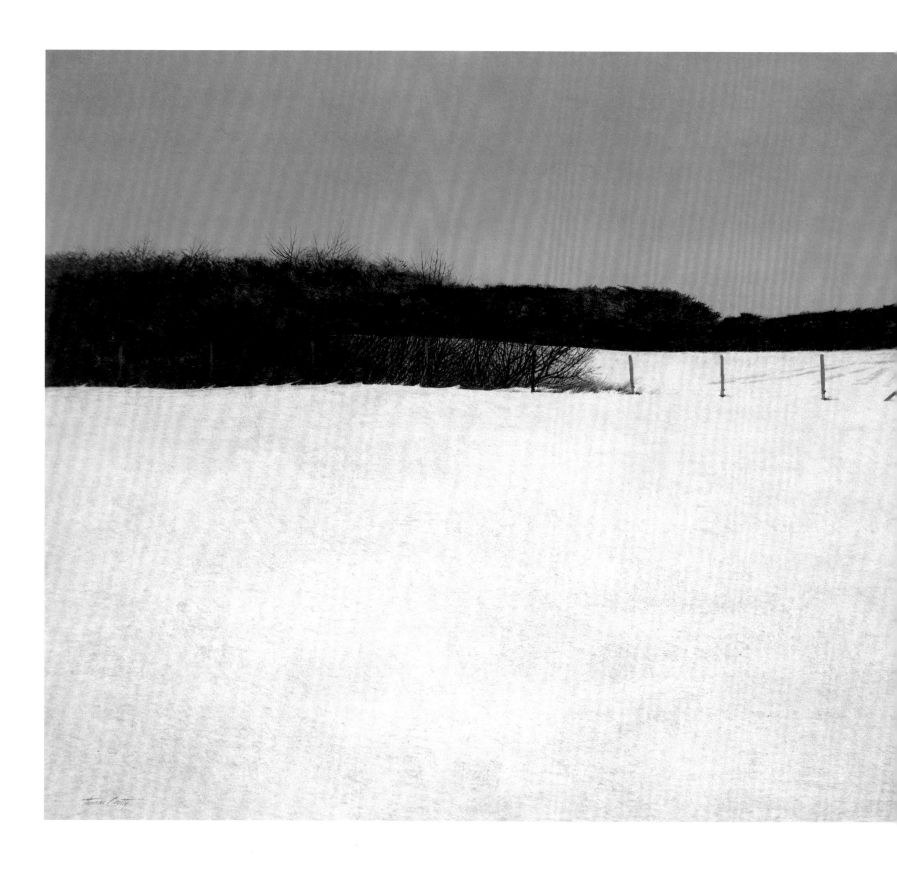

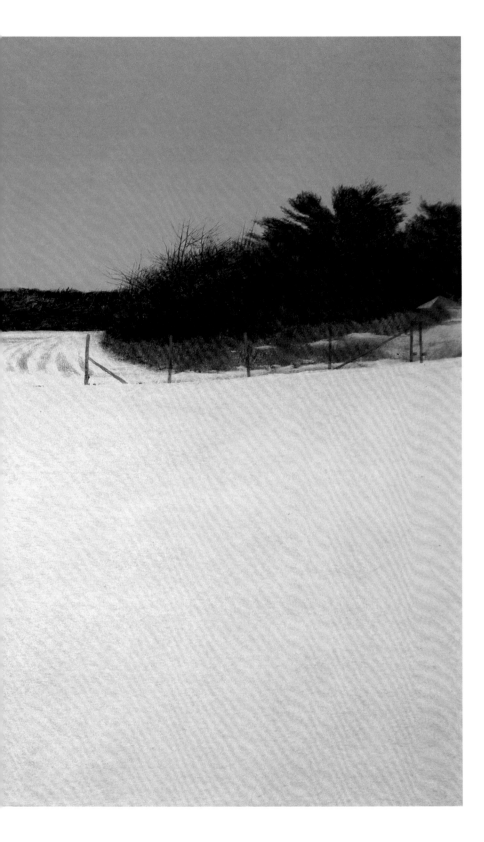

the placid solitude of Maine in winter. **Wolfe's Neck Pasture** is typical of the spatial openness and wide view of his unspoiled landscapes. Seldom depicting the snowstorm itself, Crotty concerns himself with its aftermath, when all is pristine and calm. Over half of the horizontal composition is dedicated to depicting the varying whites and undertones of the fresh snow on an empty field in Freeport. A small fence bisecting the picture plane opens onto rolling fields, its tiny vertical rungs echoed in the surrounding tree trunks. The gray sky is cloudless, and a small glow of light appears above the tree-filled dark brown hills at the mid-ground horizon line. Everything is reduced to the minimal in Crotty's simple arrangement of muted color planes. When the artist began to turn his attention to isolated landscape motifs, his work took on a poetic, almost luminist presence in its unhurried, contemplative approach and respect for nature's planar geometries.[28] Clearly Crotty was struck by the privacy and solitude that familiar places acquired during the height of winter. "I like nothing better than to poke around in the snow," he muses.[29]

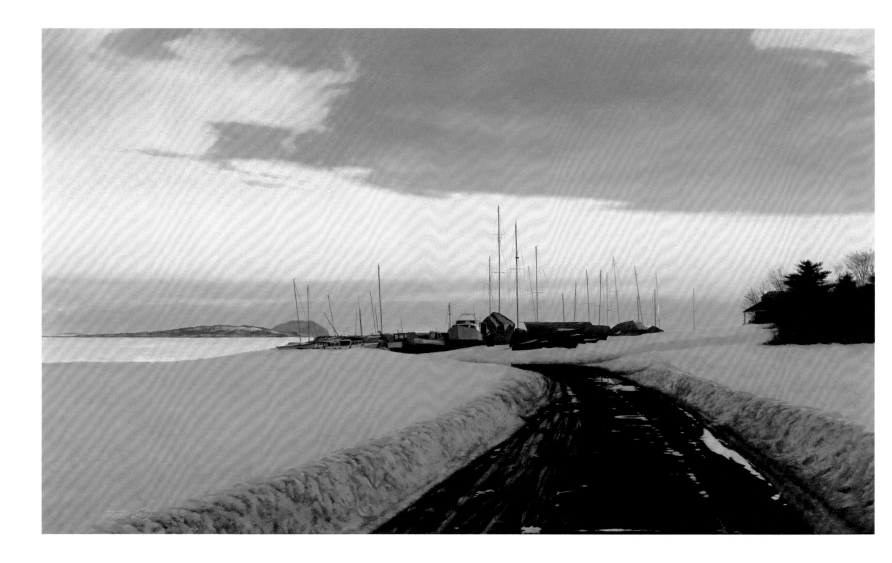

50 DOLPHIN MARINA AND EAGLE ISLAND, ca. 1985

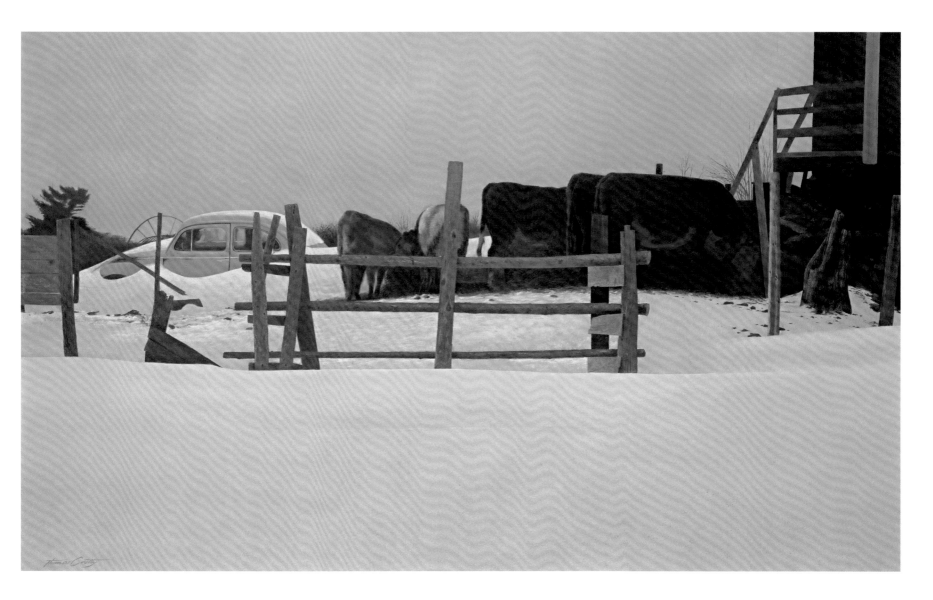

CHARLES S. PAYSON, 1981

SAILING

Since early childhood, Crotty's first love was sailboats, and after his experiences at Boston Park Yacht Club and Lee's Boston Community Boating, he never lost his appetite for sailing and racing. With over 3,500 miles of in-and-out coastline, hundreds of offshore islands, and countless nooks and crannies for dropping anchor, Maine is a sailor's paradise. "I love it here because you can hop on a sailboat and be surrounded by the coast of Maine; it's everywhere," says Crotty.[30] In 1977, he had the pleasure of watching the America's Cup races in Newport, Rhode Island, as a guest on Charles Shipman Payson's yacht, *Saga*. A Maine native, Payson (father of John Whitney Payson and husband of the arts philanthropist Joan Whitney Payson) had a year earlier promised his important collection of seventeen paintings by Winslow Homer to the Portland Museum of Art; additionally, he gave $8 million toward the building in 1983 of an I. M. Pei addition to the museum named in Payson's honor. Crotty had always admired Winslow Homer's work. As one of America's foremost marine painters, Homer had depicted the same rocky Maine coast that inspired Crotty. In a special three-part series in the *Maine Sunday Telegram* describing the state of the arts in Maine, Crotty wrote:

> Consider the accomplishments of Charles Payson. Single-handedly, he gave Maine its most important collection, and almost single-handedly gave us our

Thomas Crotty sailing Joseph Lee's thirty-foot English sailing lifeboat, 1953

most important art institution, the new Payson wing of the Portland Museum of Art. For Maine it was the cultural event of the century.[31]

An avid photographer, Crotty took a number of pictures of Payson in Newport for a commission by the Portland Museum of Art to paint the philanthropist's portrait. The result is a watercolor (p. 52) depicting the businessman at leisure "leading the whole pack of spectator's boats out to the race course."[32] From Payson's yacht, Crotty was also able to do some sketches and take some photographs of Ted Turner's famed *Courageous* in the races. Nineteen years later, inspired by the elegant beauty of a pair of passing sailboats at dusk, he painted **Newport 1977.** In a letter to Turner, Crotty described the work:

NEWPORT 1977, 1996

Hull drawings for the thirty-five-foot sailboat *Cailin a Mara,* designed by Thomas Crotty, 1978

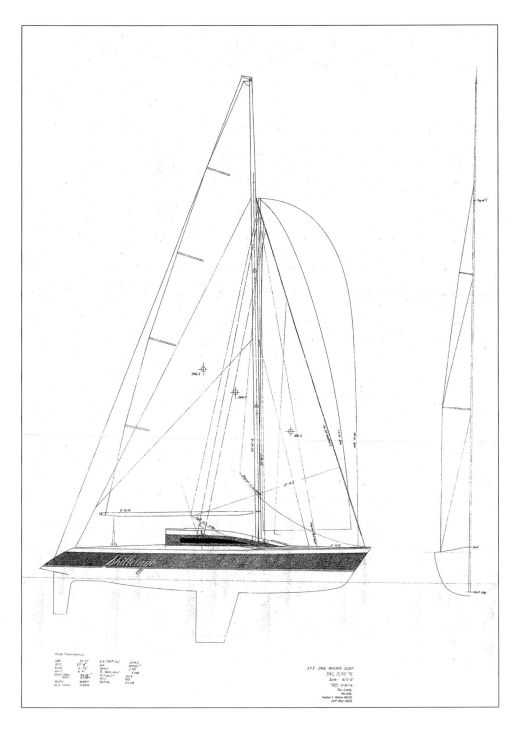

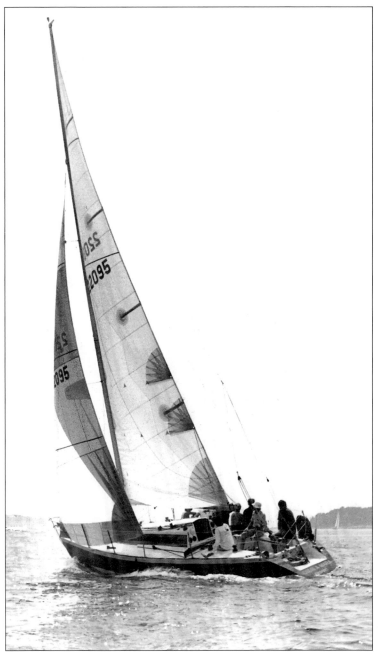

The *Cailin a Mara* at the start of the Monhegan Race in 1985

Sail plans designed by Thomas Crotty for the *Cailin a Mara,* 1978

I have recently completed a painting of *Courageous* and *Australia* which I think is a very good one.... This painting is quite subtle and focuses on the wonderful light we saw on the last leg of one of the races.[33]

Despite his great love of sailing, sailboats are a rare theme for Crotty because the artist believes that it is "hard to make a painting that transcends the actual sailboats."[34] "But," as he says, "designing sailboats is a different matter."[35] In 1978, Crotty took on the major challenge of designing his own sailboat. Instead of painting, he spent the entire winter making carefully engineered, mathematically precise, and meticulously rendered graphic plans for a thirty-five-foot coldmolded racing/cruising sloop. The *Cailin a Mara* (Gaelic for "Sea Nymph") was launched in 1980, and since then, Crotty has sailed and cruised the coast of Maine from Casco Bay to Winter Harbor. Alone on his sailboat in the quiet of dusk or dawn, Crotty began his ritual of photographing the deserted islands and rocky coasts (only accessible by boat) that would become the subjects of many of his best paintings. **Barred Islands** is a fine example of Crotty's awed respect for this precious shoreline acreage on the Barred Islands, adjacent to Fairfield Porter's Great Spruce Head Island in the middle of Penobscot Bay. Here Crotty focuses on the complex patterns and tones of the rocks, contrasting them to the calm stillness of the clear, expansive sky and the quiet waters that softly reflect the evergreens of the surrounding islands. Even in winter, Crotty makes visits to the marina, when his sailboat is safely out of the water and protected under plastic next to his home. **Dolphin Marina in Winter** (p. 58–59) depicts an off-season view of a South Harpswell marina in the moody glow of winter dusk. The sky is a brilliant mix of azures and oranges, lit by a setting sun; snow blankets the open beach area in a gentle, peaceful world where all is frozen, deserted, and still.

BARRED ISLANDS, ca. 1993

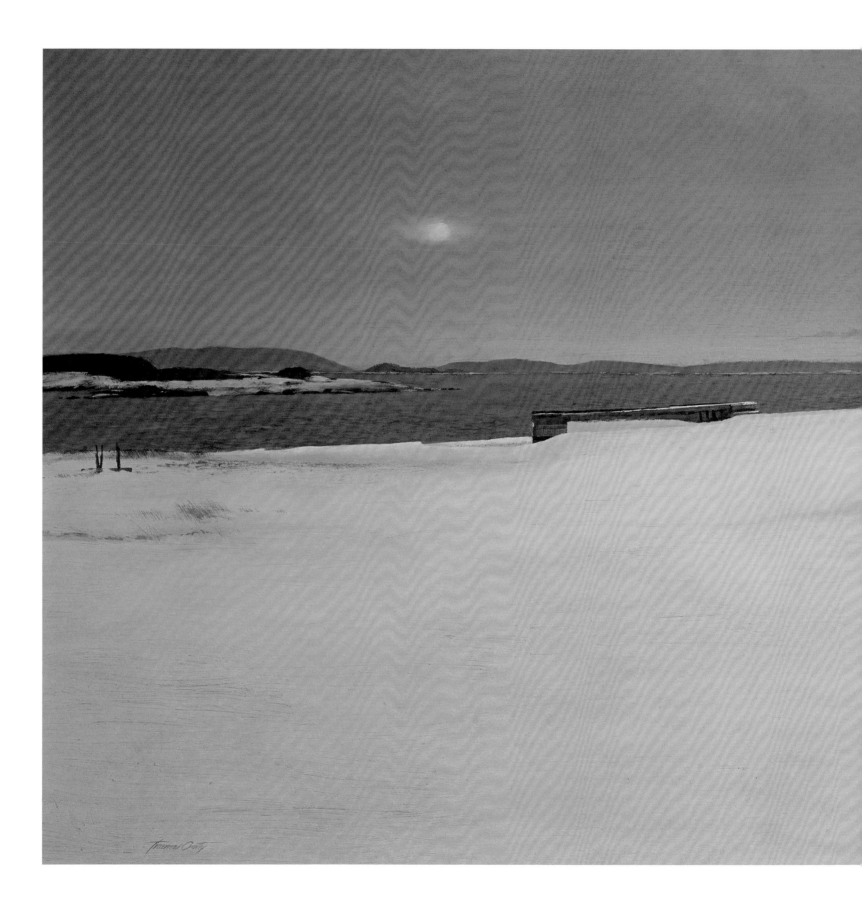

DOLPHIN MARINA IN WINTER, ca. 1984

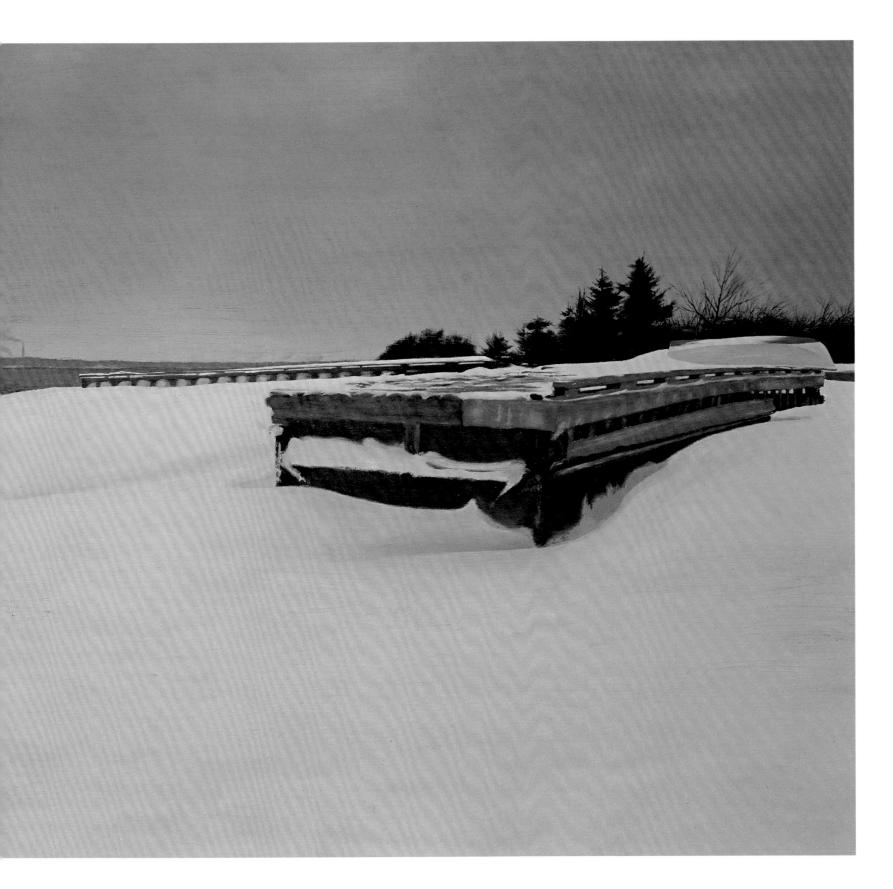

MARSHALL POINT PROMENADE, ca. 1985

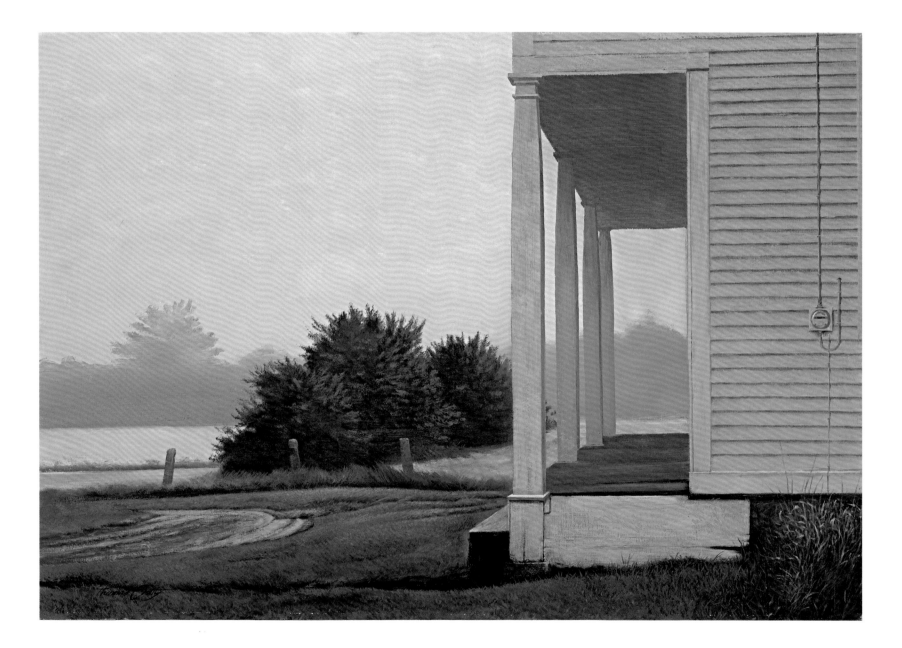

AUBURN CHURCH, ca. 1986　　　　　　　　　　　　　　　　　　　61

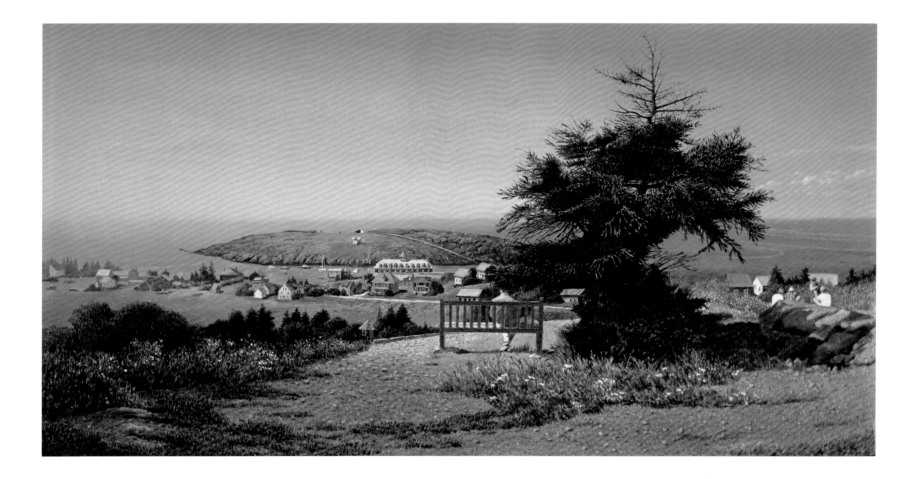

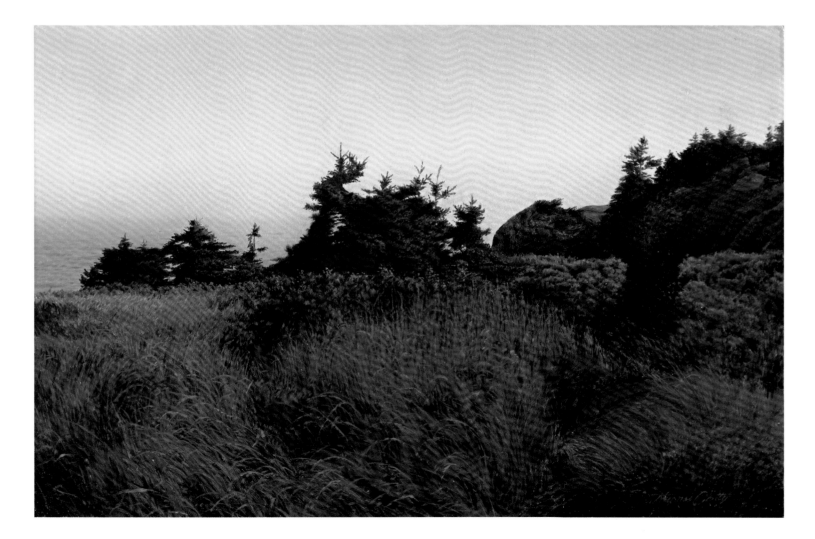

MONHEGAN, ca. 1993 63

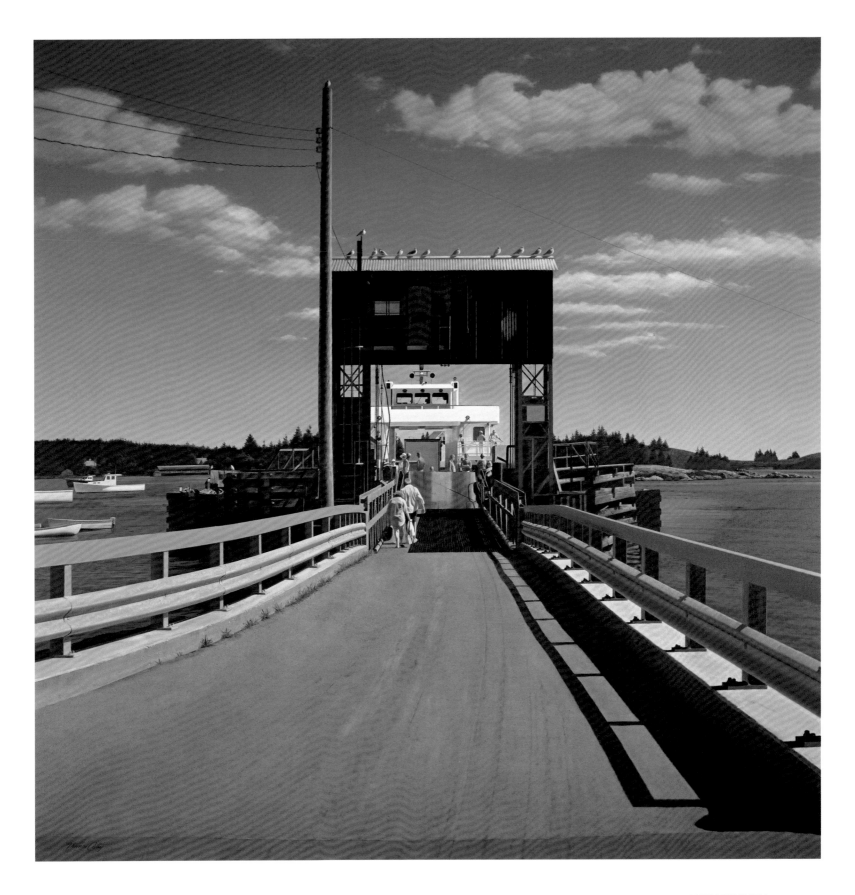

VINALHAVEN, ca. 1995

ARTISTIC MATURITY

After purchasing his first 35mm camera in 1969, Crotty combined photographs with drawings, studies, and his imagination to create his paintings. In the 1980s, however, he began to rely more fully on his camera as a direct source. **Vinalhaven**, Crotty's painting of the ramp leading to an island ferry, resembles a wide-angle photograph with its clean, hard-edged lines and precise illusionism. There is great depth of field in this sunlit painting, with everything in focus—from the geometric shadows of the ramp's railing in the foreground to the trees and clouds in the distance. Using techniques popularized by such photo-realist masters as Richard Estes, Ralph Goings, and Robert Cottingham, Crotty was able to create landscapes in which change and motion are frozen to a second in time. He recalls,

> I was reading Louis Meisel's great book on Photo-Realism and was in the chapter on Richard Estes when, wow, it was like he was reading my mind. He was talking about how the camera allowed him to be completely spontaneous about his subjects. He didn't want to think about them at all—just intuitively shoot the pictures. I had felt exactly the same way. The whole world changes when you look at it through a great lens—especially if it is a zoom-lens, which allows you to effectively move back and forth in the subject three- or four-hundred feet without moving an inch. The compositional possibilities become amazing.[36]

Thomas Crotty painting *Johanna,* acrylic on masonite, 1973

View with Jaquish Island, a work in progress when photographed (top taken December 22, 2002, and bottom taken January 18, 2003) records Crotty's painting process. A typical canvas averages two to three month's time.

Using single photographic prints as well as several collaged together to create a more panoramic view, Crotty paints his carefully constructed works of art. He describes his approach:

> Sometimes I draw just looking at the photos—or I use a grid transfer process. If I project photos I have to make serious corrections to photo distortions.[37]

The artist relies primarily on a limited palette of ultramarine blue, burnt siena, and yellow ochre, adjusted with cadmium red and yellow, and Indian red, because "they are the colors that correspond amazingly well with nature."[38] He continually balances the abstract geometry of the composition and manipulates light and his very limited palette to achieve his desired effect. The most important element in an image for Crotty is what he calls a compositional dynamic.

> It's that something that elevates a subject above the ordinary, even though it might already be wonderful, to the state of being special—something very special, unique, and with a powerful compositional quality. This cannot be invented or contrived. It is the result of an intensive search within your very own soul. It has taken years to even begin to think that I can feel these compositions. If my work has any real merit, it is because of the compositional qualities it rests upon.[39]

Illustrated here are two stages in the creation of Crotty's recent painting of Jaquish Island. The final result, **View with Jaquish Island**, reinterprets the photographed motif with immaculate stillness and electric clarity.

Looking at the photographs documenting the development of *View with Jaquish Island,* Crotty observes:

> Snow has qualities that we see and it also has other qualities that we know are there. It has its own color while it reflects everything around it. I very seldom paint snow with a layer of white paint. As you can see here, I'm starting with a textured toned underpainting—usually in a color complementing (warm or cool)

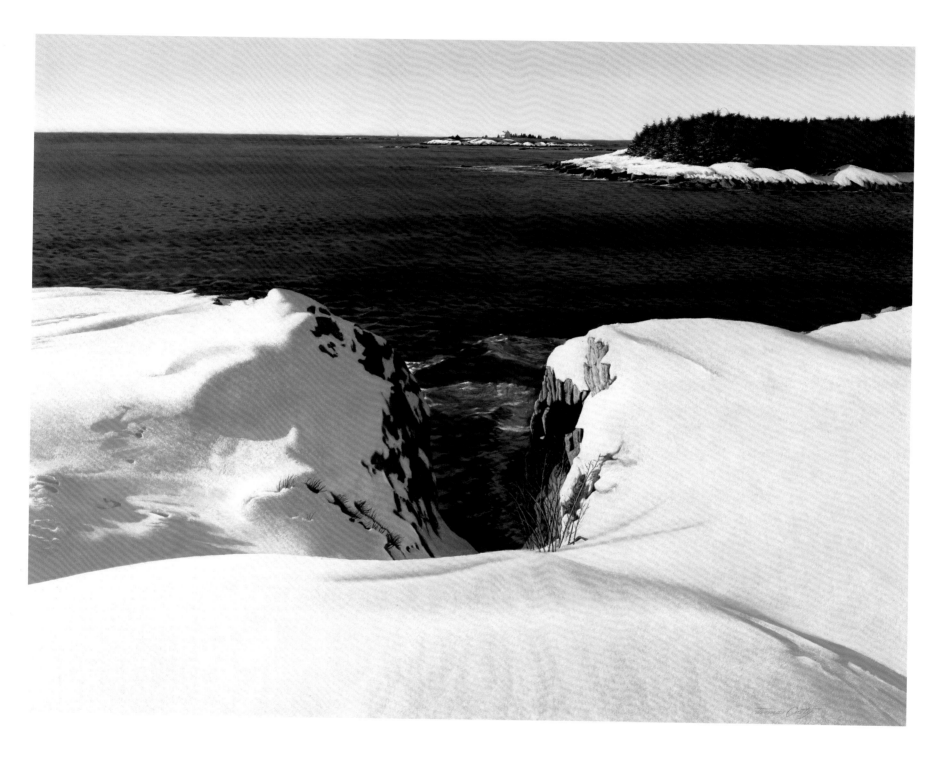

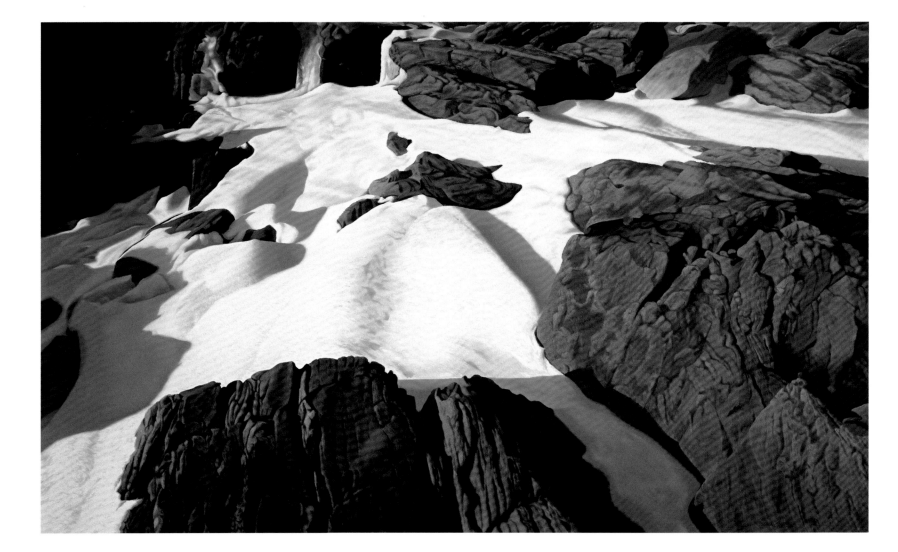

SNOW LEDGES II, ca. 1992

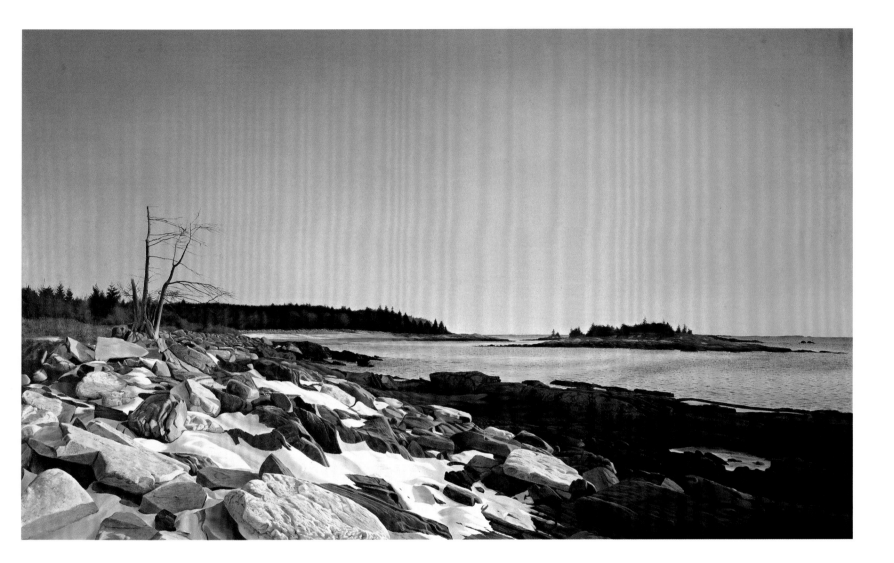

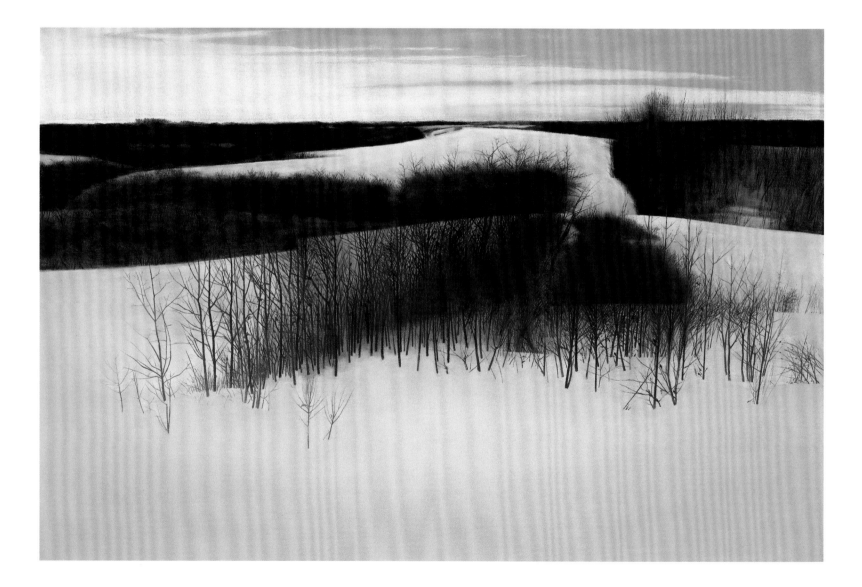

CUSHING IN WINTER, ca. 1990

the final color. This actually works best on a smooth panel, as all the texture you create remains. Canvas has a tendency to absorb delicate and subtle elements. I try to retain some of the presence of that under-painting in the finished work. I build the layers of texture with stiff brushes, often fan brushes. If I lose that texture and translucency, it all becomes dull and boring. It is always a challenge and I'm never as successful as I would like to be. Someday, maybe I'll be able to paint snow as well as John Laurent.[40]

In 1980, Crotty decided to change from acrylic paint to oil paint, a medium that allowed him to refine his already meticulous sharp-focus technique. Oils offered him greater flexibility, ease of manipulation, and freedom to combine transpar-ent and opaque effects in full range in the same painting. Crotty explains, "I had been infatuated with the idea of acrylics probably as a product of Mass Art and Beverly Hallam in the 1950s. But I really hated to paint with these plastic paints. When I finally switched to oils about 1980, that's when I started having fun."[41] **Frost Gully, New Snow**, one of Crotty's first oil paintings, highlights the luminous effects possible with oils. Here, Crotty captures the gentle slopes, dark bushes, and blue and purple reflections on the fresh snow at his familiar gully. Although from a distance the painting appears photographic, closer examination reveals a variety of textures, as for example in the tiny brushstrokes

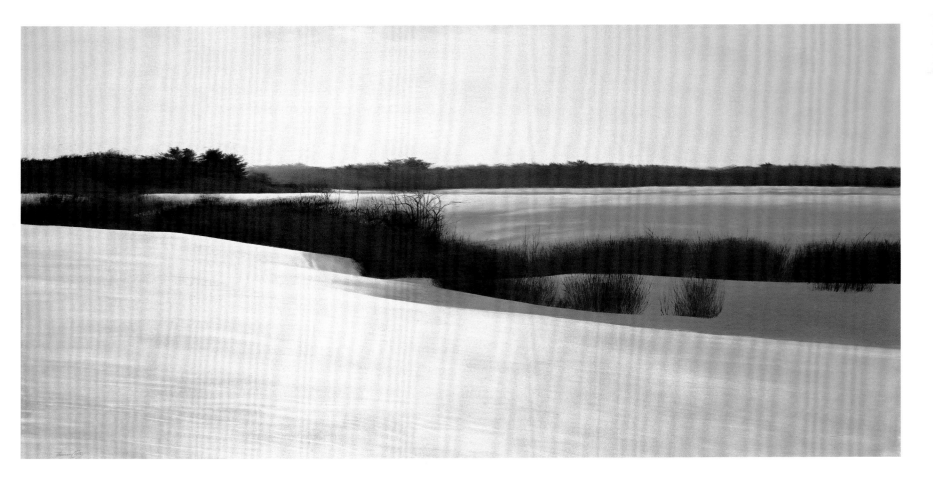

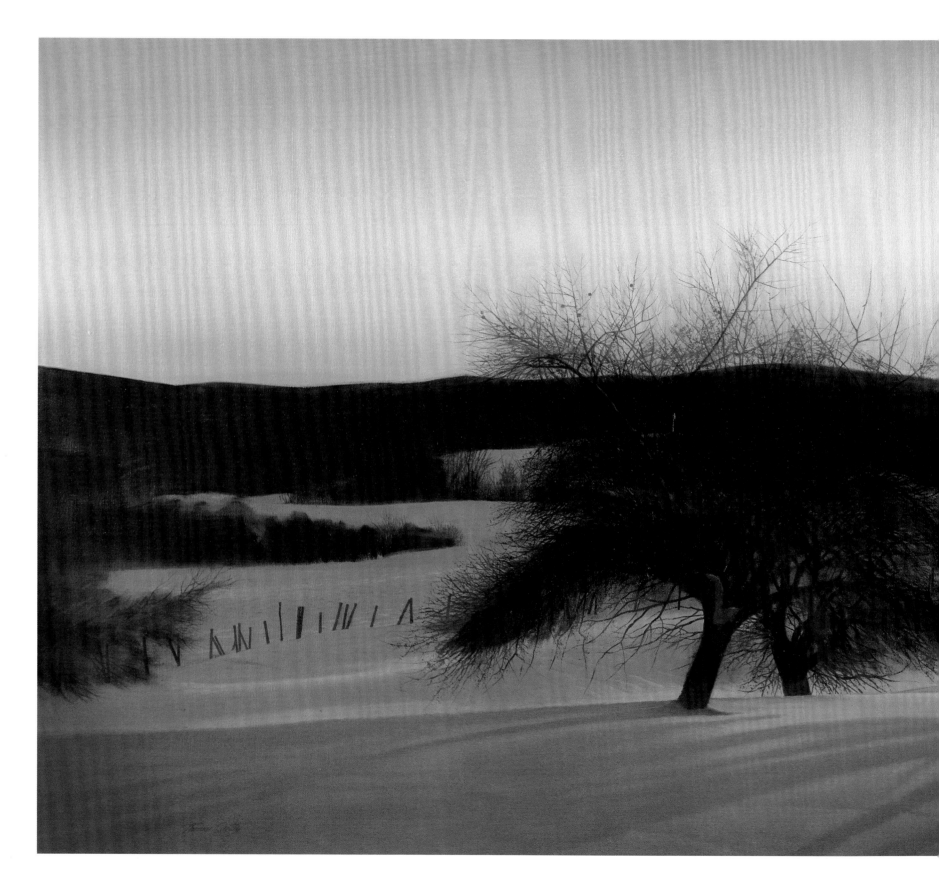

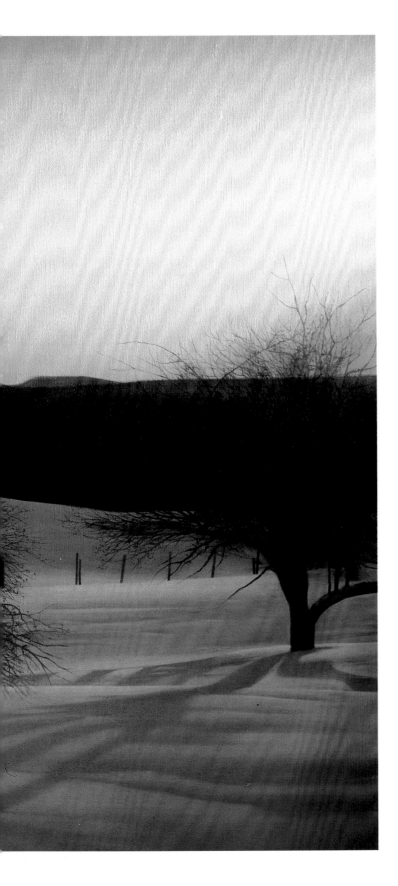

ORCHARD AT DUSK, ca. 1997

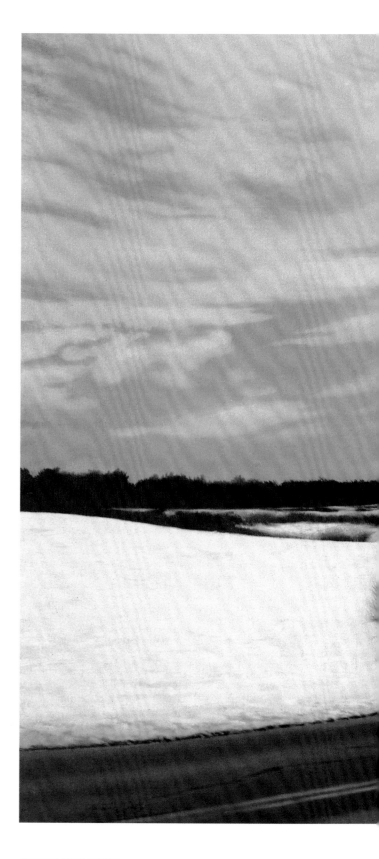

BUNGANUC ROAD, ca. 1992

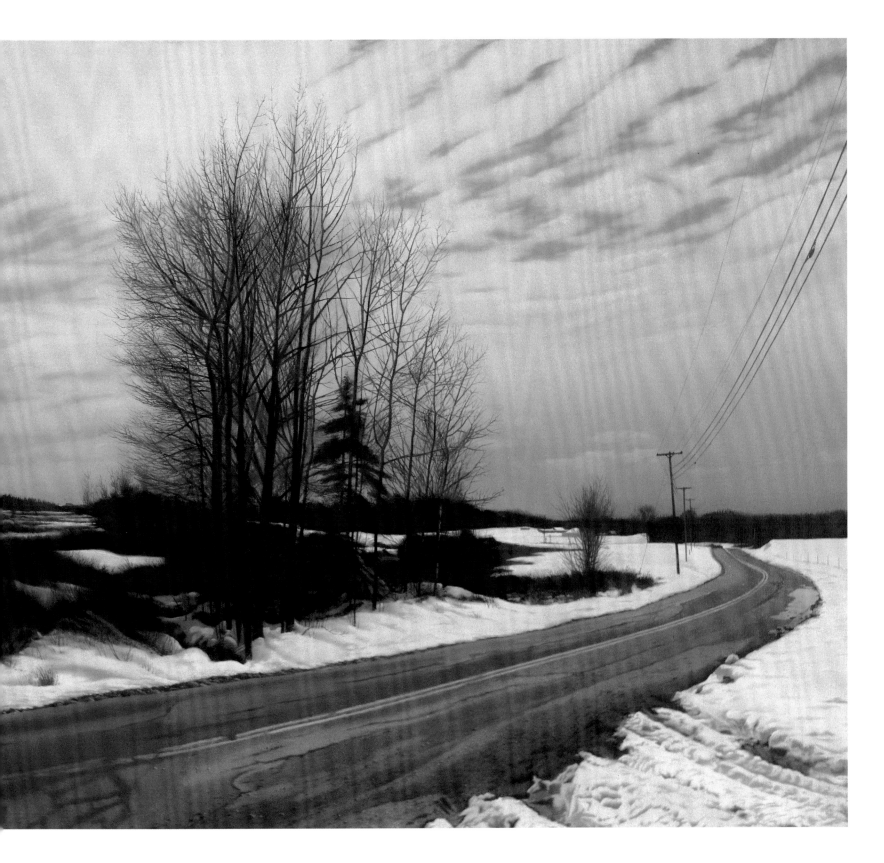

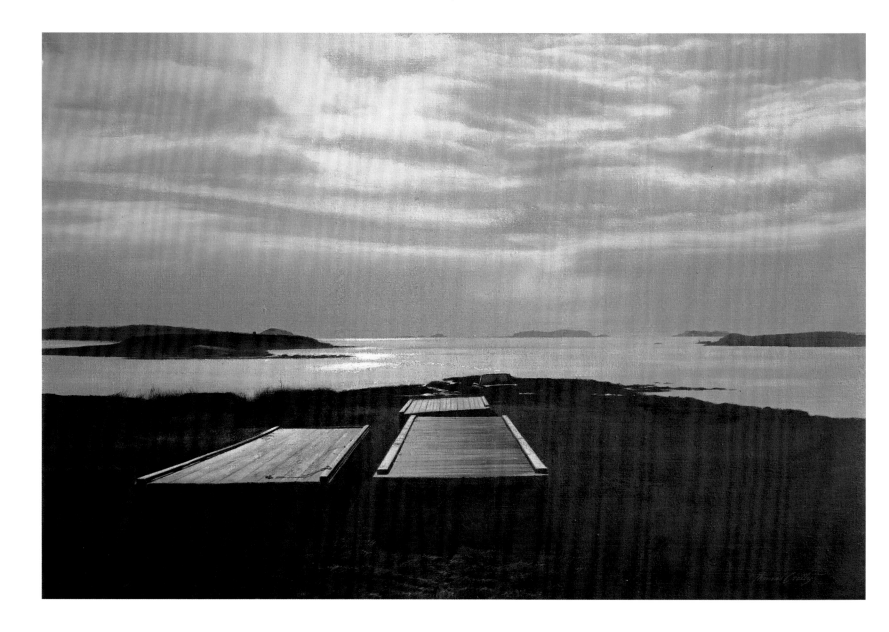

that make up the soft snow. Not fond of the qualities of air-brush, Crotty prefers the visual residue of the painting process.

Unlike the photo-realists, Crotty's thematic reference point has always been nature and not the reproduced image, and his work does not share their detached matter-of-factness and urban edge. There is an inherent regional romanticism in Crotty's choice of subject matter and palette. As much as he is concerned with perfection of technique—and his self-critical eye dictates constant revisions and over-paintings—Crotty makes romantic, realist paintings as a product of his reverence and awe for what he is looking at. "My paintings," he confesses, "are very simply my feelings about nature and the world we live in. For me, it's Maine, and that is incredible."[42] Maine's variations in climate and terrain, sparsely settled open spaces, and magnificent rocky shorelines are what inspire Crotty's reverent landscapes.

Since about 1981, Crotty's art has remained focused on re-creating the noble beauty of the sky, islands, and waters of his chosen world. **Migis Lodge** (p. 78–79) is a poetic image of a midday in winter looking out at the east side of Sebago Lake; the ice creates a translucent cover for the still body of water, especially where it fuses with a layer of snow at its edge. Absent is the summer congestion of vacationers to the upscale Migis Lodge resort; Crotty opts for the off-season view from the shoreline, focusing on the placid, horizontal vista of the semi-frozen water, picturesque islands, magnificent blue sky, and distant mountains.

Crotty does not totally deny the presence of man. In the bucolic **Broad Sound**, three hauled-out floats and a lone pick-up truck indicate the now silent area's potential for seasonal activity. The wooden floats, lit by a rising sun, act as vectors leading to the glorious silvery ocean and distant islands; the

Examples of photographs in Thomas Crotty's studio used in combination with drawings and studies to create his paintings

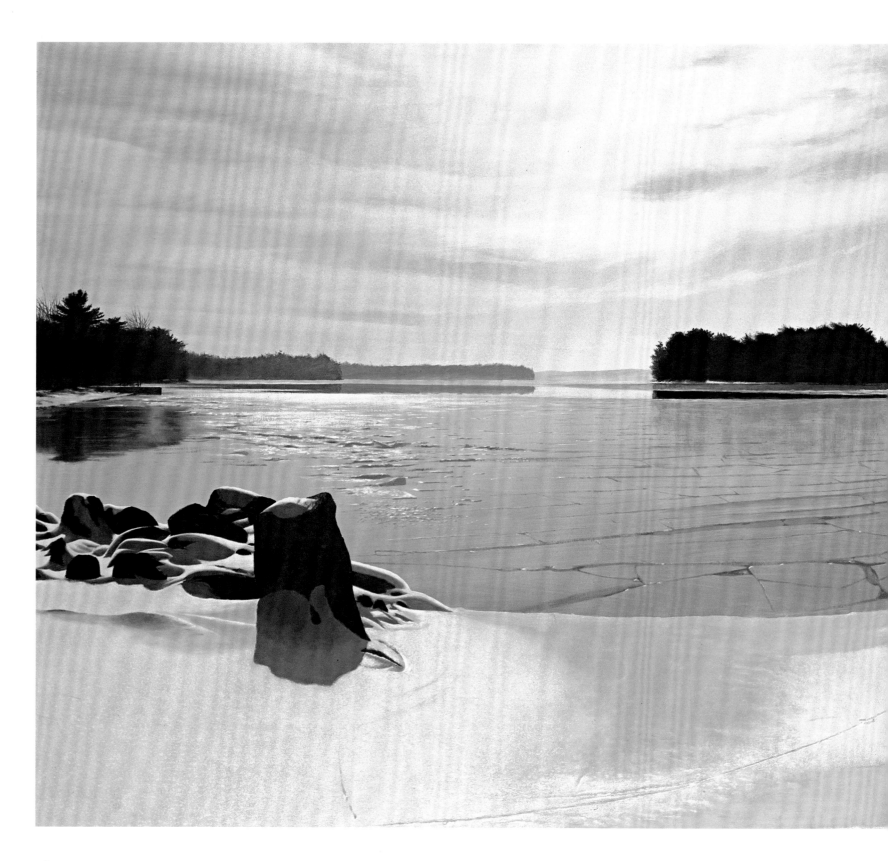

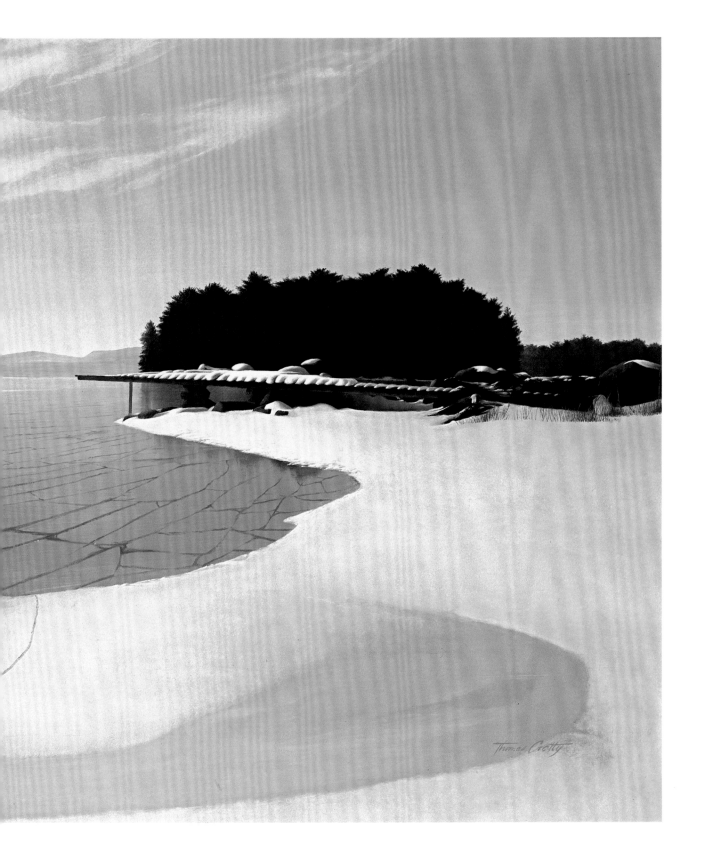

MIGIS LODGE, ca. 1986

image seems to contain Crotty's secret longing to set sail on this magnificent portion of South Harpswell. In **Pleasant Hill Road**, Crotty focuses on the abstract geometry of the intersection of two Brunswick roads. Banks of snow along the roadside dusted with brown and gritty dirt contrast with the pristine snow of the surrounding fields. The thin black lines of telephone wires slicing against the sky emphasize the wide-open vista. A road sign and distant farms bear witness to local civilization.

Crotty has become an expert at re-creating and enhancing the dreamy surreal effect of ice on the water. In **Sea Ice** (p. 84–85), he uses the same cool palette of blues, whites, and purples for both rocks and sea to create a work of an arctic-like, otherworldly quietude and expansiveness. Everything is frozen in time in the stillness of winter in a painting that some might consider a second-generation surrealist dream image.

Crotty's most transcendent paintings focus on the twilight hours in tranquil, pristine settings. He reveals the glorious beauty of sunlight reflecting on the water of Casco Bay through a group of cropped foreground trees on a wintry day in Freeport's Wolfe's Neck Woods State Park in **Wolfe's Neck II** (p. 87). The vertical, golden reflection of the sun on the water echoes the patterns made by the group of dark trees on the shoreline; Crotty's love for the romantic effect of the dawn reveals itself in a great number of paintings in a variety of scales. In the large panoramic 20" x 40" **Spring Point Sunrise** (p. 86), Crotty illustrates the orange and purple splendor of early morning at the shoreline, and in the small

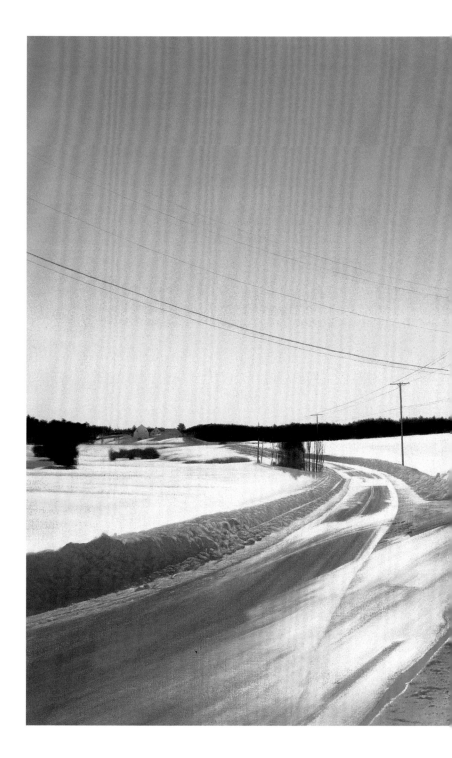

PLEASANT HILL ROAD, ca. 1989

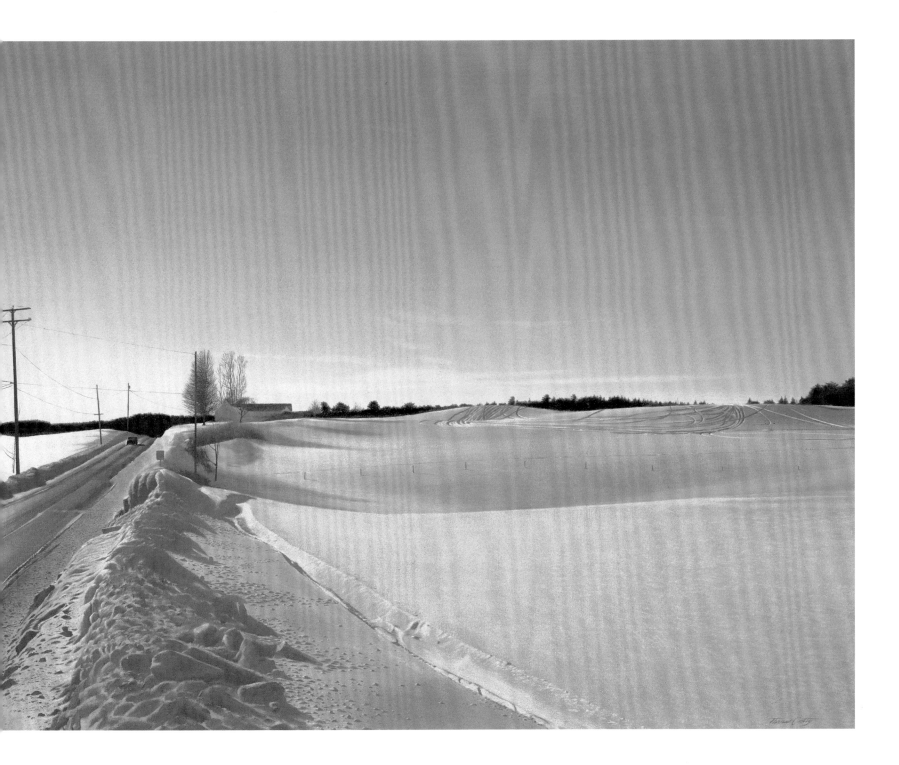

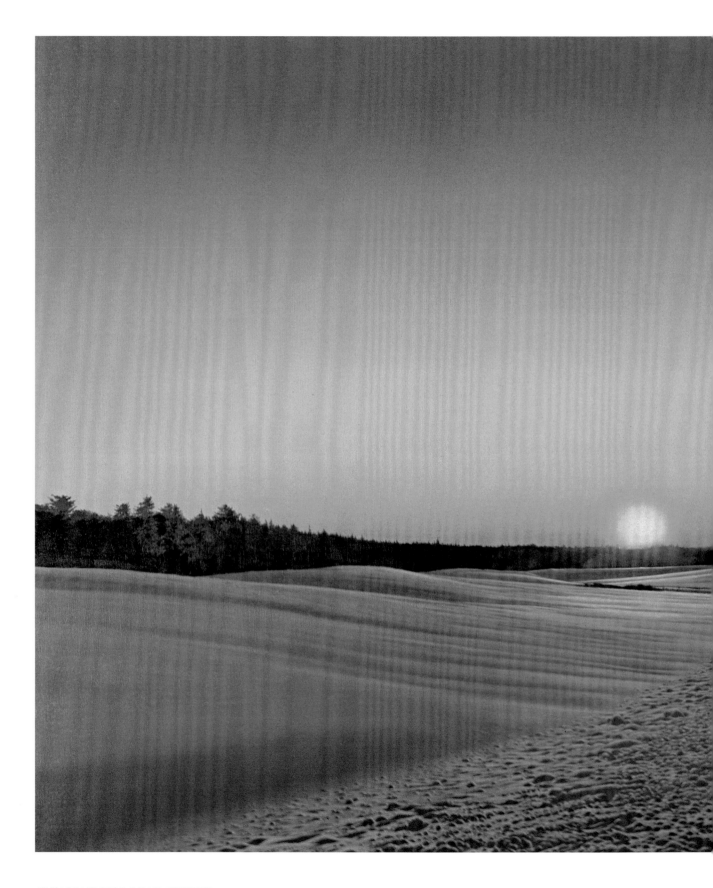

PLEASANT HILL ROAD, SUNSET, ca. 2000

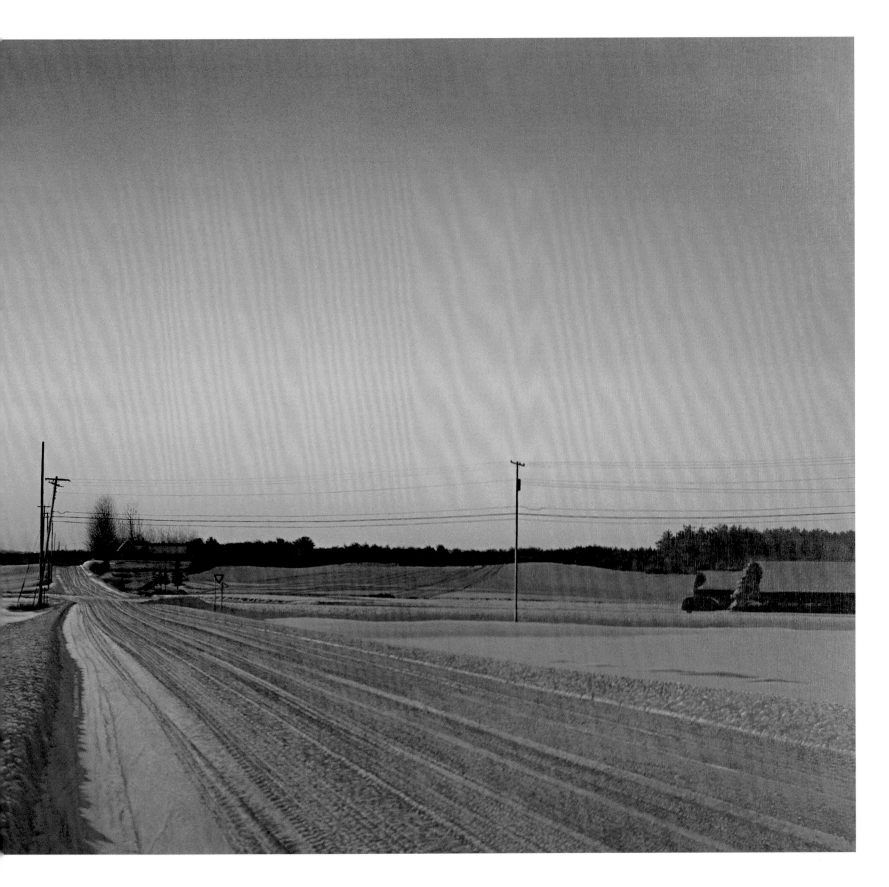

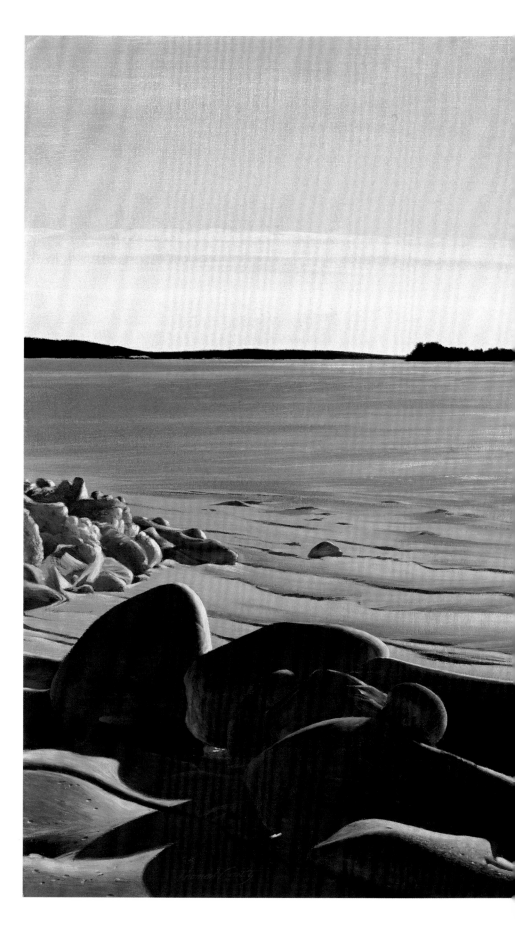

SEA ICE, ca. 1988

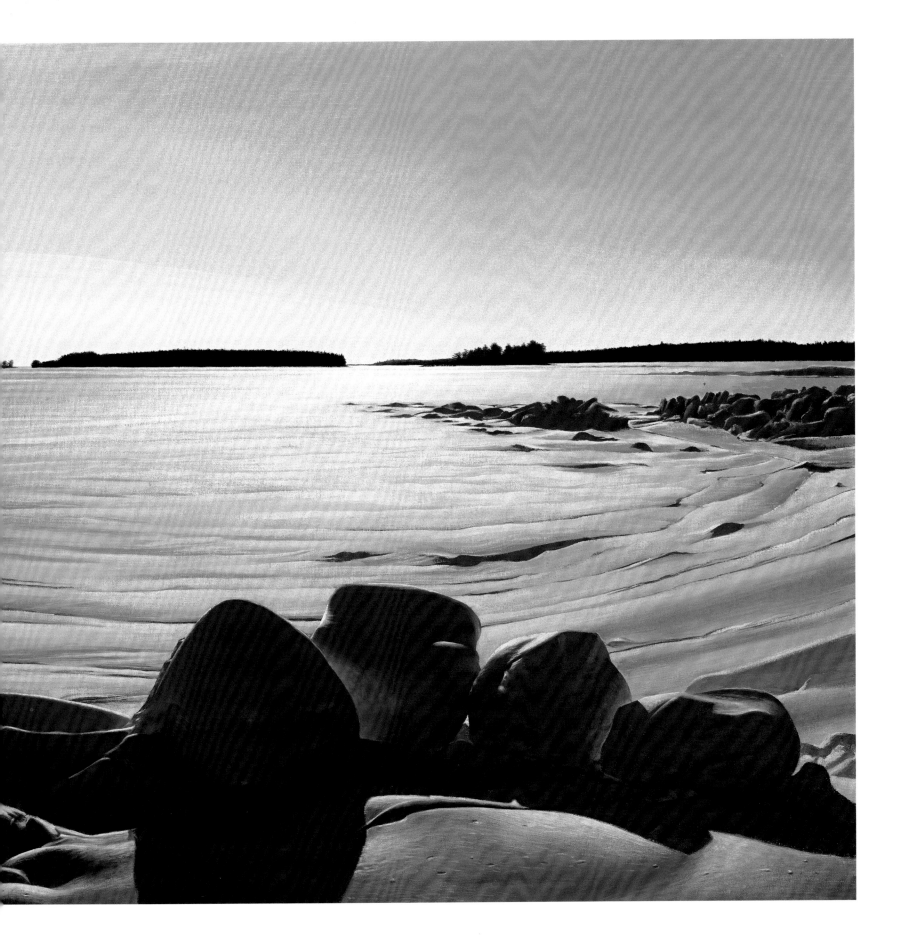

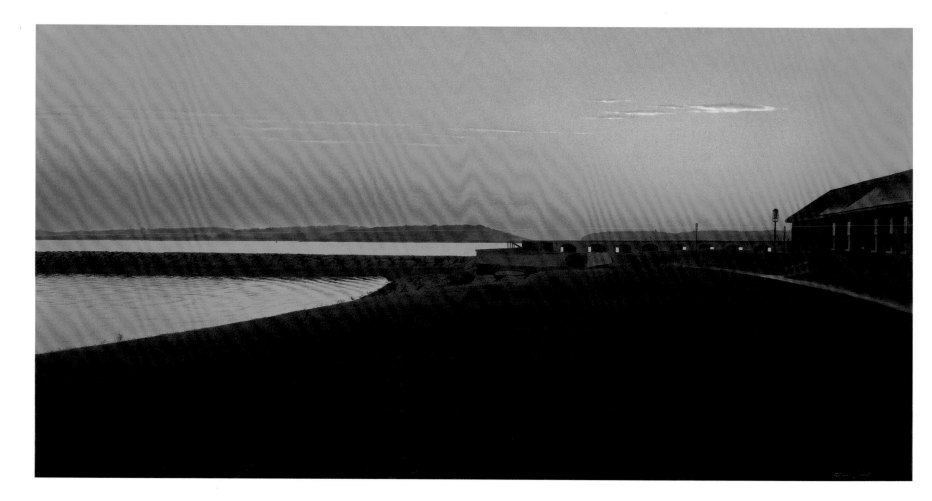

9" x 12" **Sunrise—Deer Isle** (p. 88), the focus is on the hazy sunrise over the ocean. A lover of the shadowy and mysterious semidarkness of dusk, Crotty painted **Basin Cove, Dusk** (p. 92–93) as a study in wide horizontal planes. Gentle bands of white snow, dark sand, and semi-frozen gray and white waters suggest a haven under a dimly lit sky. In **Dusk— Wolfe's Neck** (p. 89), Crotty portrays the glow of sunset as it reflects on the now placid ocean viewed through a corner of a rocky, woodland promontory. **Vinalhaven Sunset** (p. 90) is a luminous work, almost Japanese in its muted tones, flat horizontal format, and elegant simplicity. Tiny sailboats, mirrored in the glasslike harbor, and evergreen treetops punctuate the quiet horizontal composition. The soft orange ball of the setting sun makes a double reflection in the still water,

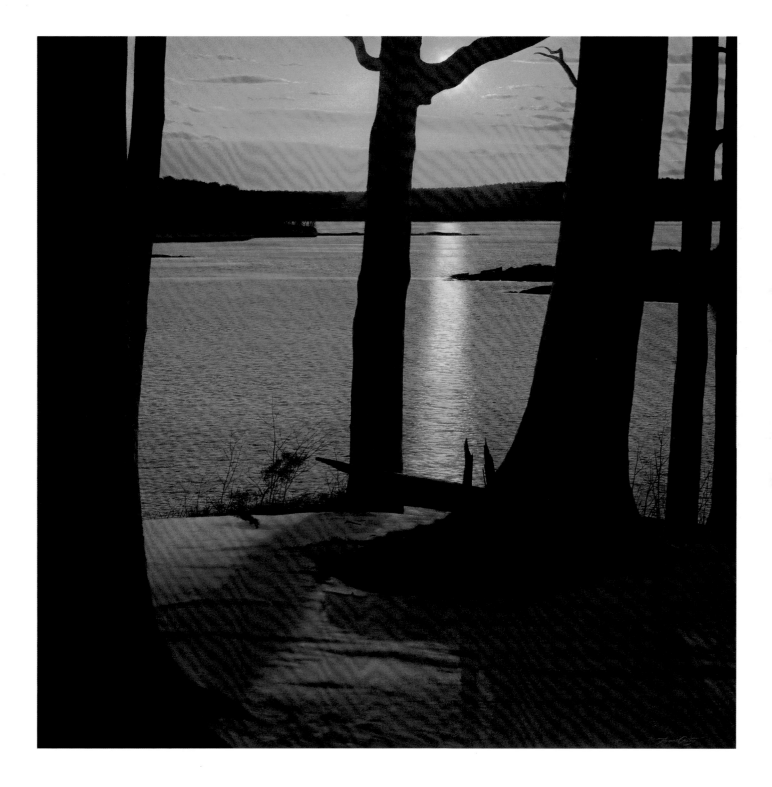

WOLFE'S NECK II, 1992

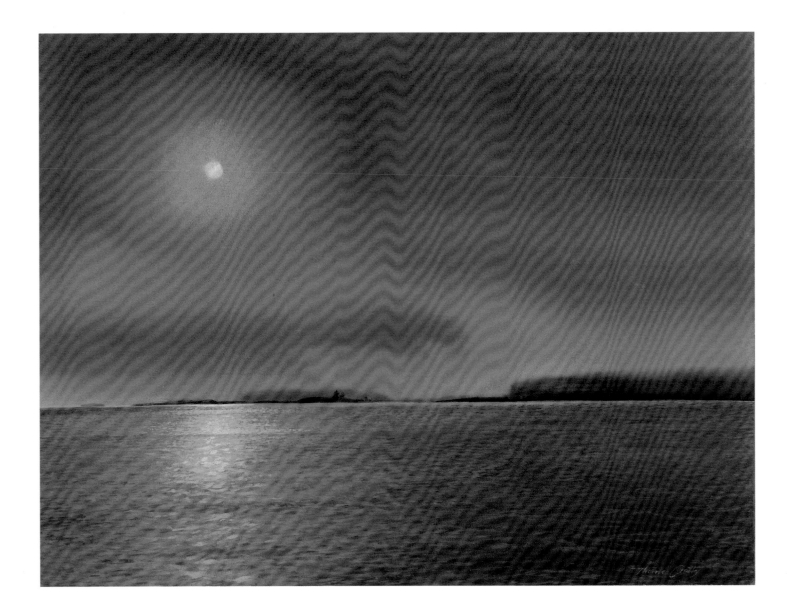

SUNRISE—DEER ISLE, ca. 1995

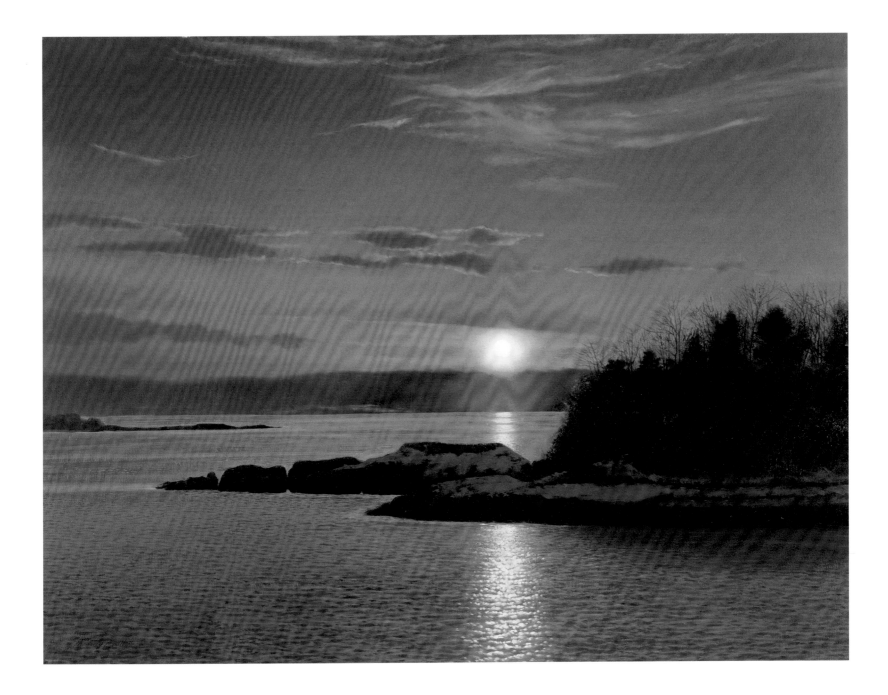

DUSK—WOLFE'S NECK, ca. 1999

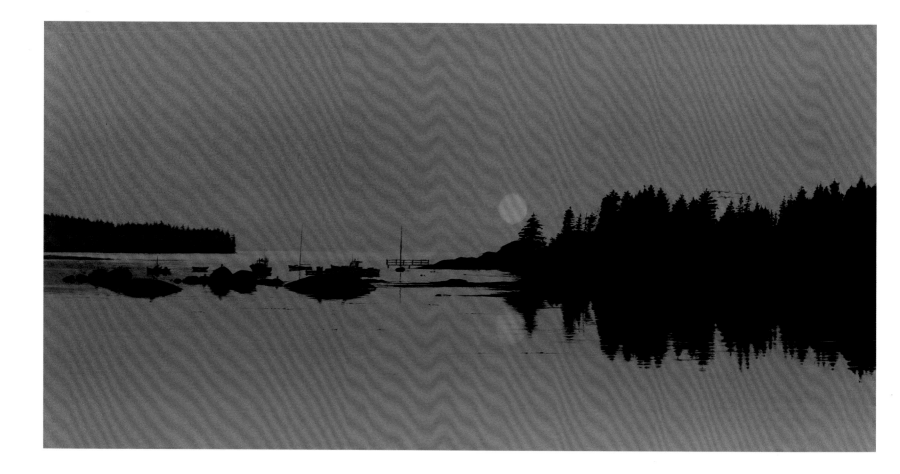

VINALHAVEN SUNSET, ca. 2001

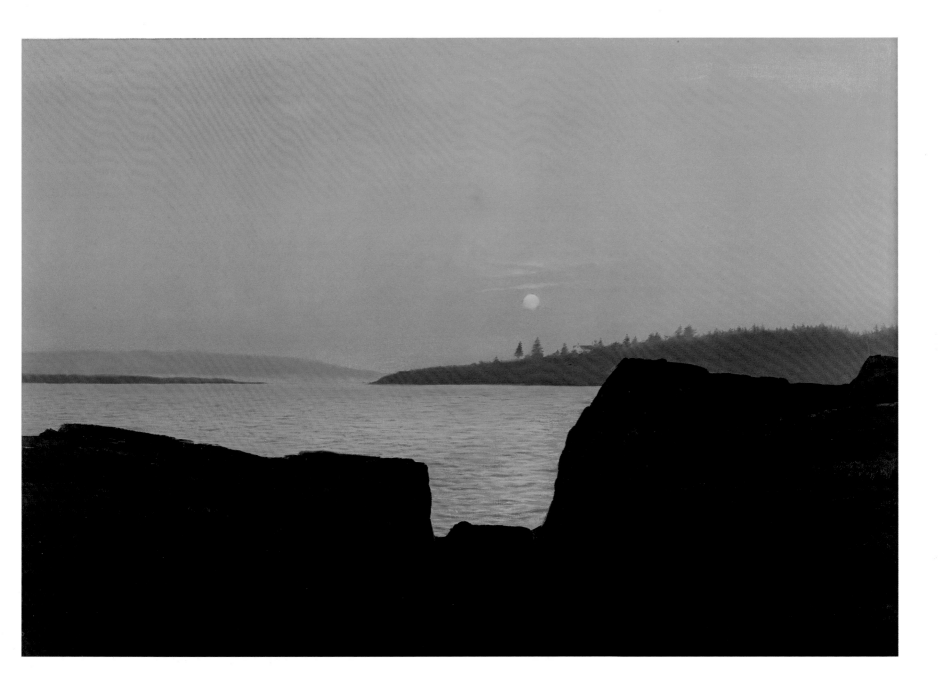

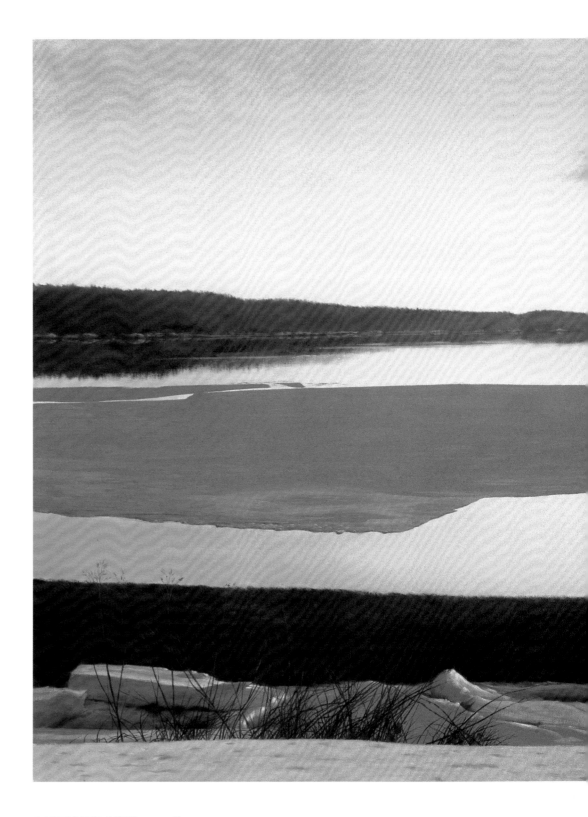

BASIN COVE, DUSK, ca. 1989

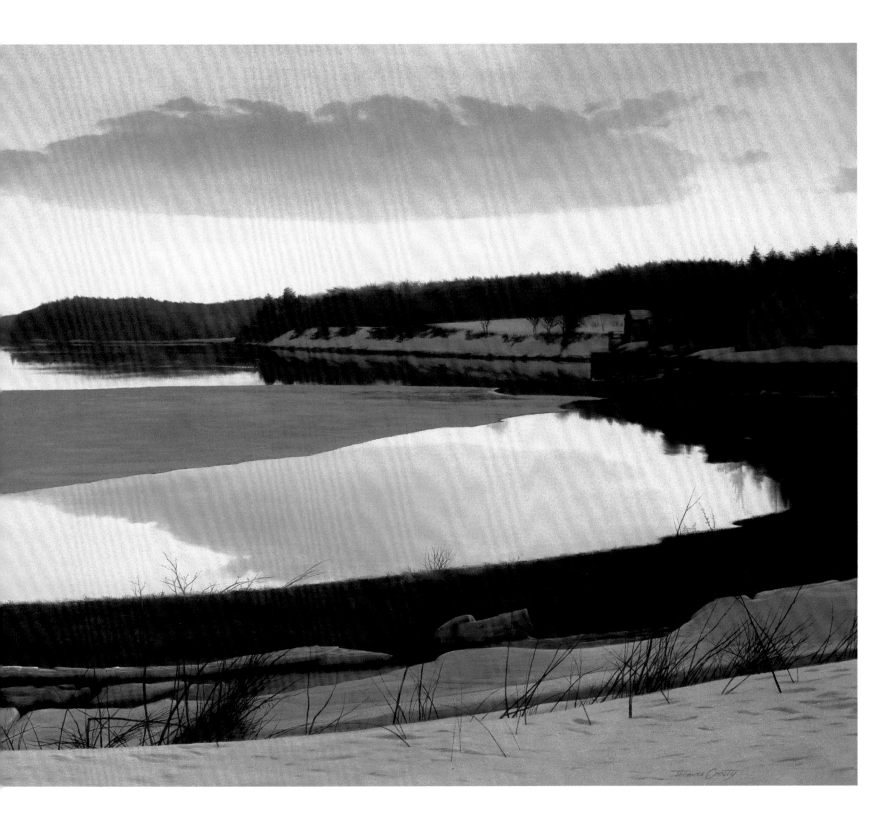

creating a striking vertical pattern. In all these twilight works, the viewer is gently urged to escape and ascend into the quiet grandeur of nature that Crotty has discovered in Maine.

Crotty is an artist who revels in studying the varying aspects of light and the seasons at a single spot. Using his camera to select broad vistas or to zoom in on favored motifs, he has already captured and painted Drift-In Beach nine times since 1995. Drift-In Beach, a small public sandy beach on the St. George Peninsula at Port Clyde, offered Crotty the opportunity to focus on how the tide creates ripples on the weathered sand and shore. In **Drift in Beach**, Crotty depicts an expansive view of the moss-and-seaweed-covered rocks at low tide. There are footprints on this vacant shore, as well as ripples and tide pools left by the ocean. In **Drift in Beach II** (p. 97), the artist closes in on a cropped view featuring translucent pools of water, rocks, and a sandbar. In **Drift in Beach VII** (p. 96), Crotty magnifies, in a magically surreal manner, how the summer sunrise reflects through two majestic rocks at the shore's edge; the ripples of water on the mud make biomorphic abstract patterns in the sand.

According to the artist, being able to experience Drift-In Beach at 4:30 A.M, to watch the light change as the sun rose, was the only benefit of the five tedious years spent attempting to restore a bed and breakfast at nearby Tenant's Harbor.

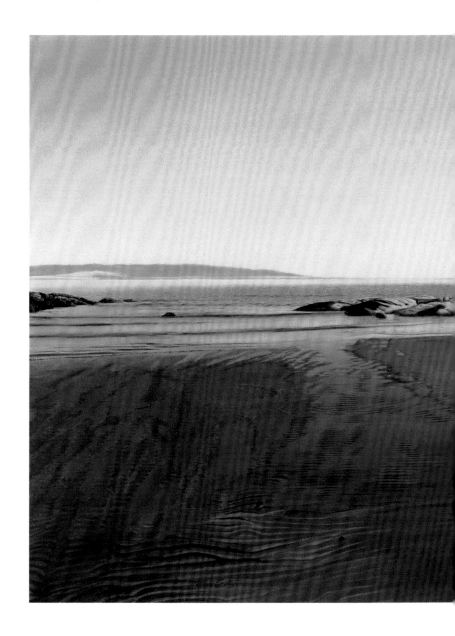

DRIFT IN BEACH, ca. 1995

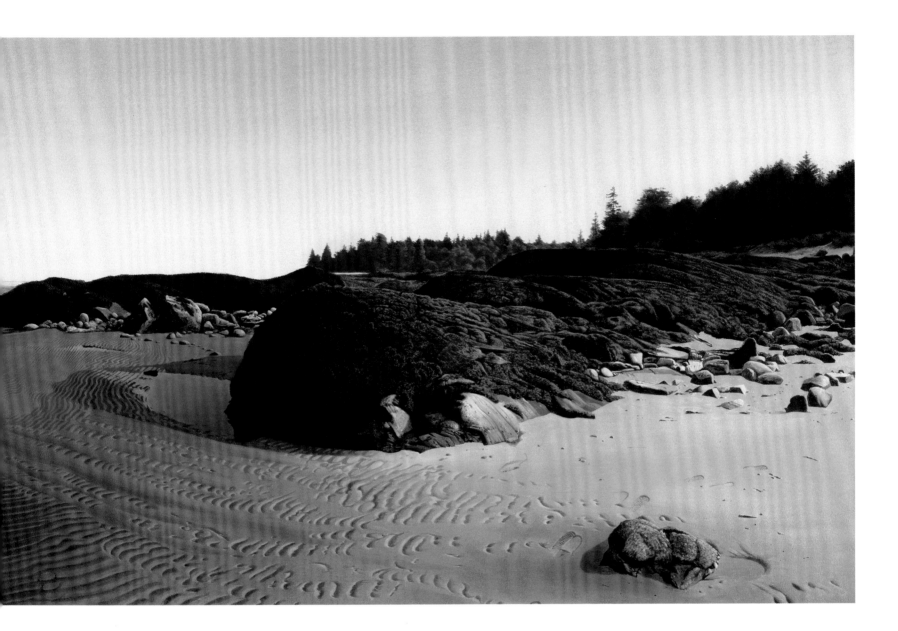

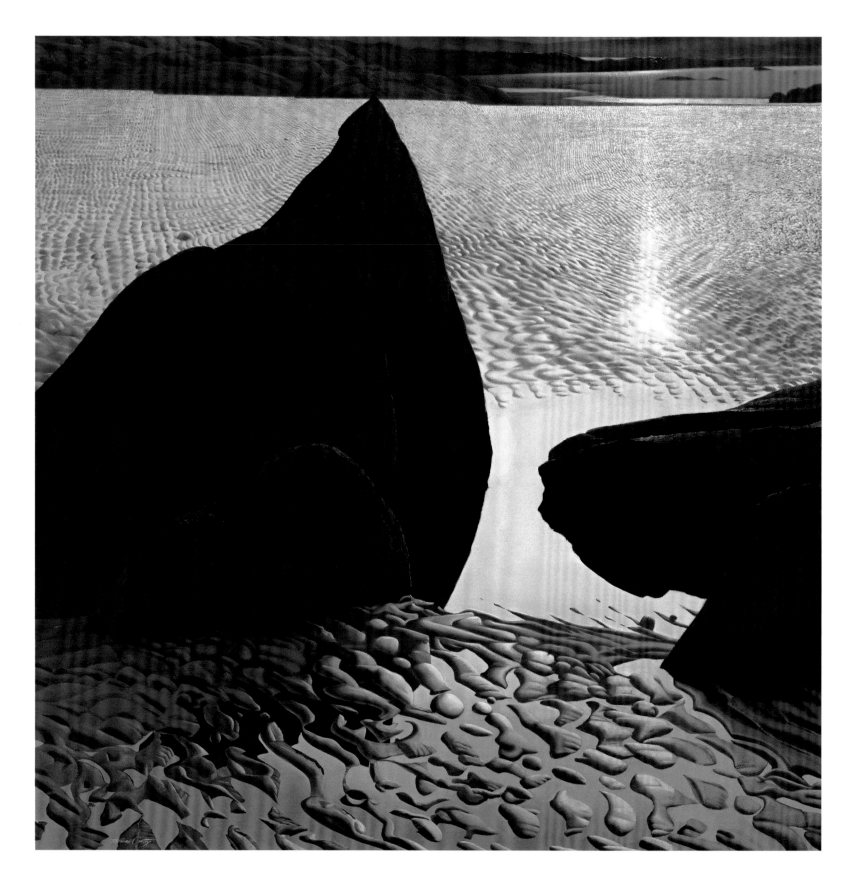

DRIFT IN BEACH VII, ca. 1996

Crotty had met and fallen in love with Pauline (Polly) Halle in 1975, and they were married in 1981. Their daughter, Erin, was born in 1982. The Crottys purchased a run-down inn at Tenant's Harbor in 1993. Their plan was to renovate it together and run the establishment while Crotty painted and sold art. This all-consuming and costly experience led to friction in their already troubled marriage. In 1997, the Crottys decided to sell the inn that had never opened; they were divorced in 1998. Erin remained with her father, reminding him firsthand about the joys and responsibilities of fatherhood, and introducing him to the beauty of ballet, her great passion as she was growing up.

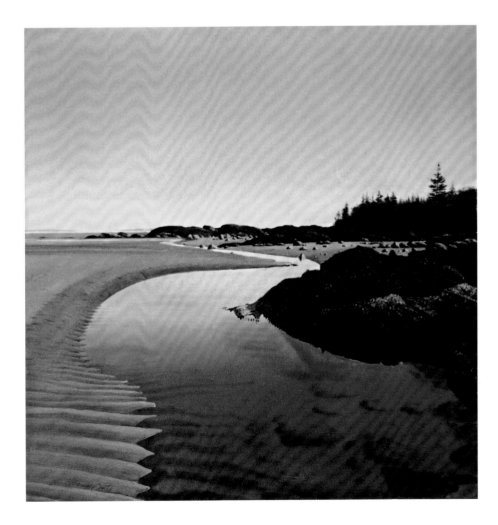

DRIFT IN BEACH II, ca. 1996

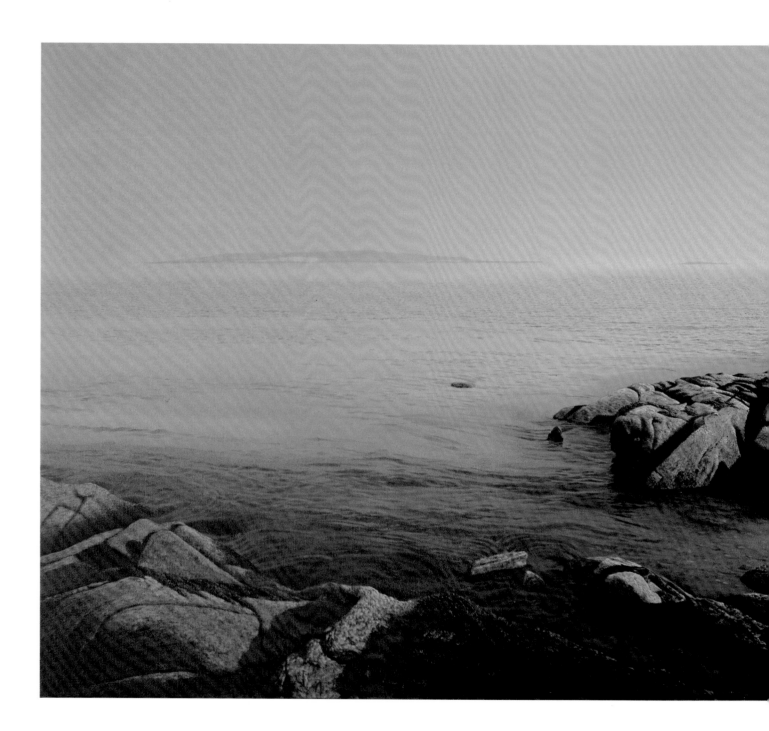

DRIFT IN BEACH IV, ca. 1996

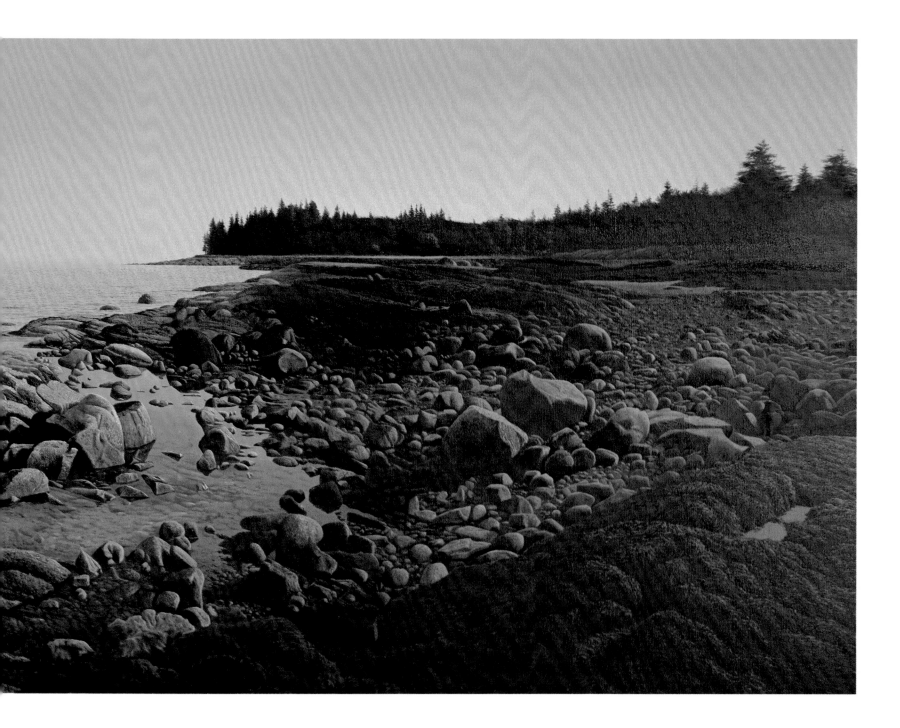

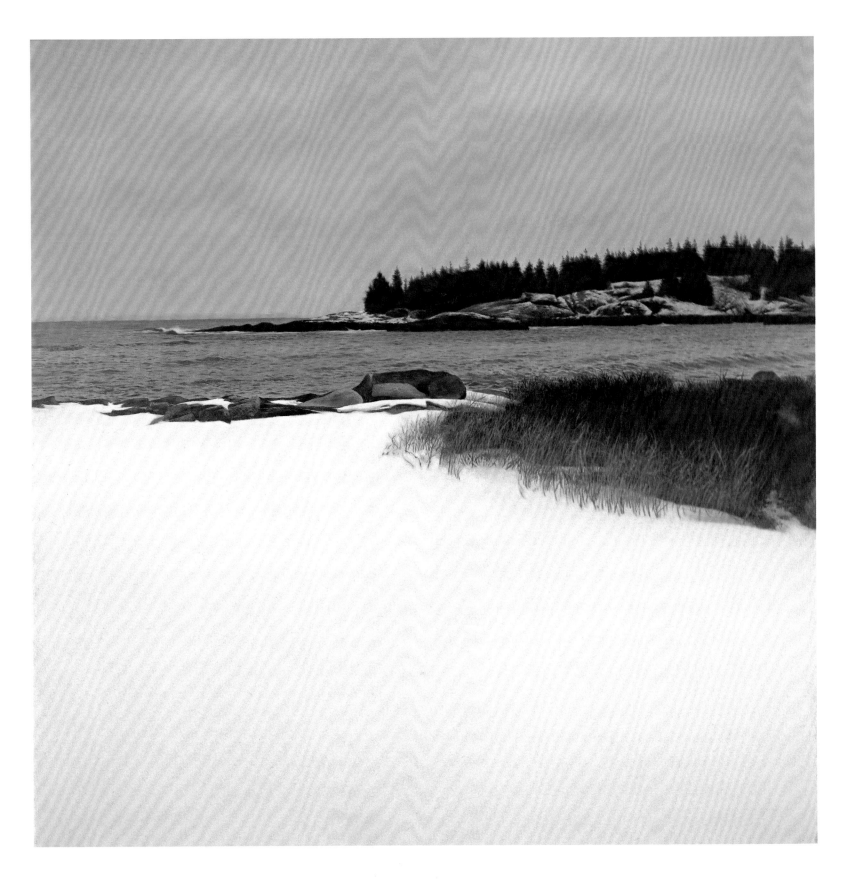

SALTER ISLAND, ca. 1990

A SOLITUDE OF SPACE

Thomas Crotty's strong spirit has never been extinguished by life's reversals. Always the entrepreneur, he dreams of creating a summer art gallery complex for Maine and New York gallery owners near Rockland. A highly opinionated arts activist, he has penned a number of articles in Maine's newspapers in an effort to build a greater audience for local artists of quality. Crotty decided in 2000 to leave the Portland art scene. He moved his gallery back to its original location in Freeport and into a new, large, light-infused space next to the old barn where the gallery began. In addition, he built a studio above it.

As when he first attended art school in the 1950s, Crotty at sixty-eight is still totally committed to what some might consider conservative values and to the concept of the timelessness of well-crafted art. He dislikes being labeled a conservative, yet he has serious reservations about most conceptual and performance art and shuns the post-modernist notion of contemporary art as a vehicle for expressing ideas, situations, or politics. Crotty describes many of today's blockbuster exhibitions as "mere propaganda or show business."[43] According to Crotty, "the political/social nihilism and revived Dadaism of the sixties in America destroyed the great progressive values that produced this magnificent free society, trashed it, and produced nothing in its place. The hippies of the sixties moved on and became cynical, materialistic yuppies who are the modern worshippers of false idols."[44]

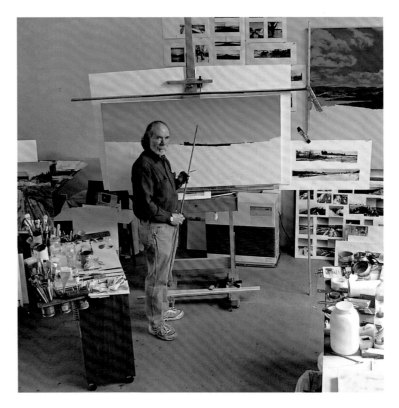

Thomas Crotty working in his new studio, Freeport, Maine, 2003
Photograph by Janvier Rollande

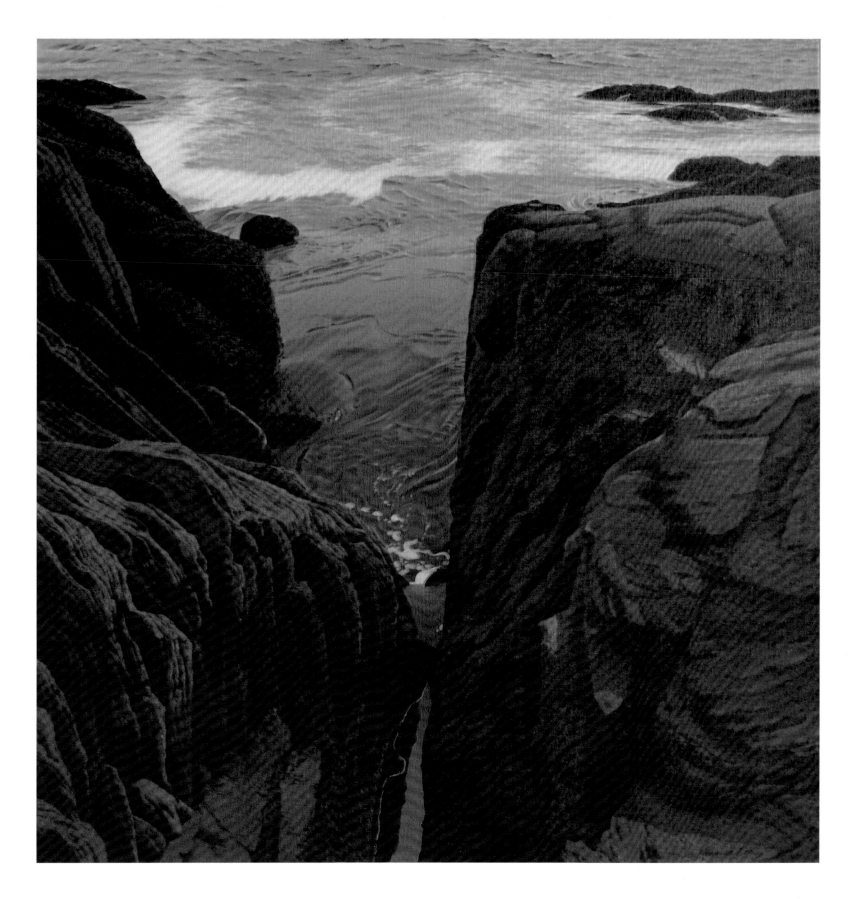

LEDGES AT BAILEY ISLAND, 2002

Despite his gritty individualism or perhaps because of it, Crotty's art continues to gain audience and attention in the new millennium. In 2000, the Center for Maine Contemporary Art in Rockport gave him a mini-retrospective, fittingly titled *Tom Crotty: The Essential Maine: Landscape Paintings*.

Light, sea, and rocks signify the essential Maine for Crotty, and he continues to explore them in his recent painting **Ledges at Bailey Island**. That same ocean that he found solace and comfort in as a young boy still flows through the weathered rocks and sustains him. In essence, Crotty's evolution as an artist coincides with his growing appreciation for the solitude and primeval character of Maine's infinite natural spaces. His landscapes, almost without exception, reflect his profound and worshipful sense of place. Crotty endows each work with a measure of his spirit and the soul of Maine. Almost thirty-five years ago, in the introduction to his first one-person exhibition, Crotty quoted from Walt Whitman's 1855 verse *Song of Myself* in an attempt to explain his own free spirit:

> Have you reckon'd a thousand acres much? have
> you reckoned the earth much?...
> You shall no longer take things at second or third
> hand, nor look through the eyes of the dead,
> nor feed on the spectres in books,
> You shall not look through my eyes either, nor
> take things from me,
> You shall listen to all sides and filter them from
> your self.[45]

The artist still keeps his Whitman reader at his desk. Like Whitman, Crotty looks for universal harmony in his own experiences. A fierce independence, a love of the land, and the will to experience his world firsthand has resulted in an art that deals honestly and passionately with the solitude of space.

—FRANCINE KOSLOW MILLER

ENDNOTES

1. Thomas Crotty, statement for *The Artist as Native: Reinventing Regionalism*, ed. Alan Gussow (Rohnert Park, Calif.: Pomegranate Artbooks, 1993), 16.

2. Thomas Crotty, interview with the author, 8 January 2003.

3. Ibid.

4. Ibid.

5. Thomas Crotty, interview with the author, 15 March 2003

6. Ibid.

7. Ibid.

8. Ibid.

9. Ibid.

10. Thomas Crotty, interview with the author, 17 January 2003.

11. Ibid.

12. Ibid.

13. Thomas Crotty, unpublished manuscript, collection of the artist.

14. John Stomberg, "From Downtown to Doughnuts: Realism and the Role of Image in Boston Area Painting," *Painting in Boston: 1950–2000* (Lincoln, Mass.: DeCordova Museum and Sculpture Park, 2002), 125.

15. Thomas Crotty, interview with the author, 27 December 2002.

16. Thomas Crotty, interview with the author, 8 January 2003.

17. In 1965, *Ralph's* won a first place award in the watercolor division at the Eastern States Exposition, which was organized by the Museum of Fine Arts, Springfield, Massachusetts.

18. Thomas Crotty, interview with the author, 8 January 2003.

19. Carol Le Brun, "Another First for Boston at Museum," *Boston Sunday Herald Traveler*, 23 April 1967, 14.

20. Edgar Allen Beem, "Support your Local Artists," *Maine Times*, 15 March 2000, 22–23.

21. Thomas Crotty, interview with the author, 30 January 2003.

22. Thomas Crotty, interview with the author, 17 January 2003.

23. Thomas Crotty, interview with the author, 27 December 2002.

24. Thomas Crotty, interview with the author, 17 January 2003.

25. Ibid.

26. Ibid.

27. *The Return to Realism: Thomas Crotty*, foreword by David C. Driskell (Nashville, Tenn.: Carl Van Vechten Gallery of Fine Art, Fisk University, 1973).

28. Luminism is a mid-nineteenth-century style of painting characterized by emphasis on depiction of light, precisely rendered detail, and a dreamily poetic atmosphere. Luminism is sometimes considered an offshoot or the final phase of the Hudson River School of painting.

29. Thomas Crotty, interview with the author, 18 January 2003.

30. Ibid.

31. Thomas Crotty, "Maine's Artists Wandering in a Wilderness," *Maine Sunday Telegram*, 9 August 1992.

32. Thomas Crotty, interview with the author, 18 January 2003.

33. Thomas Crotty, letter to Ted Turner, 5 May 1988, Crotty papers, collection of the artist.

34. Thomas Crotty, interview with the author, 18 January 2003.

35. Ibid.

36. Thomas Crotty, interview with the author, 15 March 2003.

37. Ibid.

38. Ibid.

39. Ibid.

40. Thomas Crotty, interview with Daniel E. O'Leary, 21 March 2003.

41. Thomas Crotty, interview with the author, 15 March 2003.

42. Ibid.

43. Ibid.

44. Ibid.

45. Walt Whitman, "Song of Myself," quoted by Thomas Crotty in *Thomas Crotty: Acrylics, Watercolors, Drawings* (Boston: The Guild of Boston Artists, 1969), published in *The Whitman Reader*, ed. Maxwell Geisman, (New York: Pocket Books, 1955), 22.

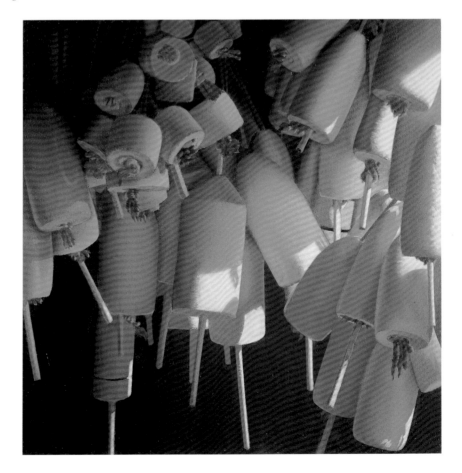

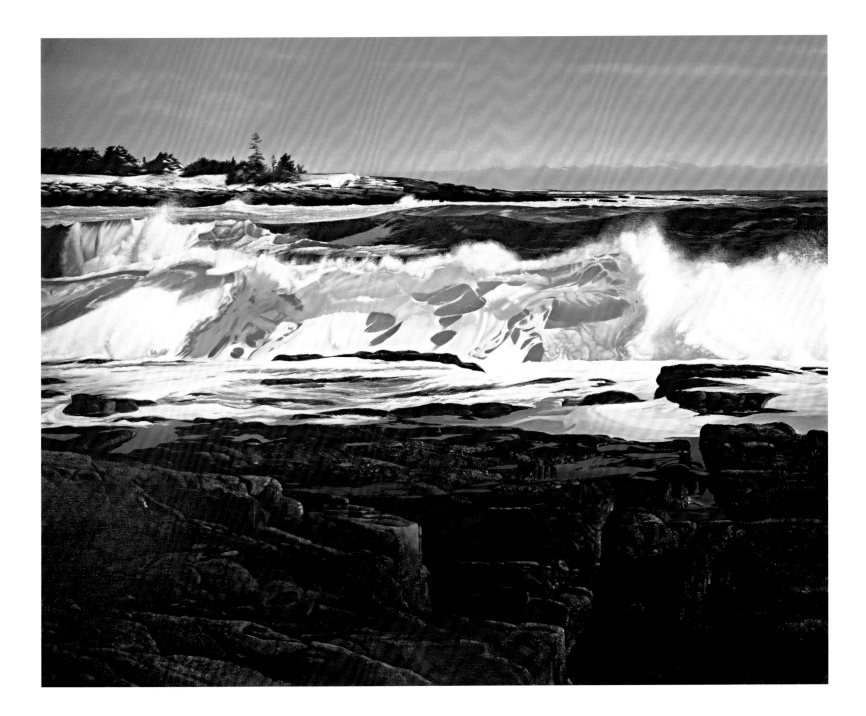

INDIAN POINT—MARCH, ca. 1992

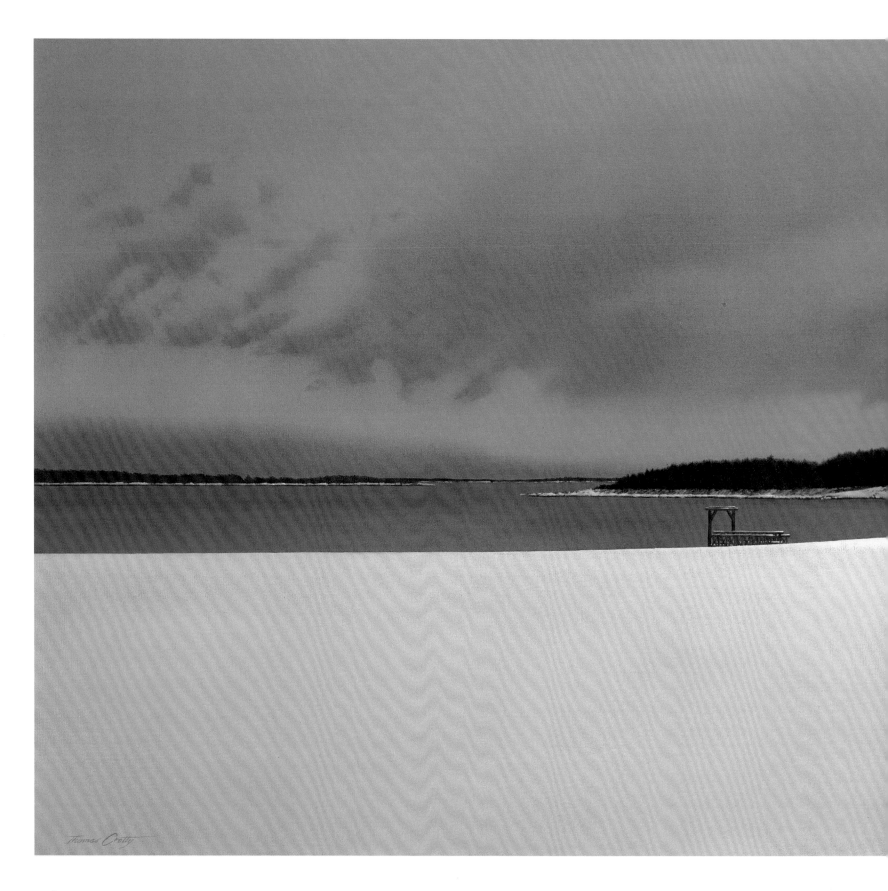

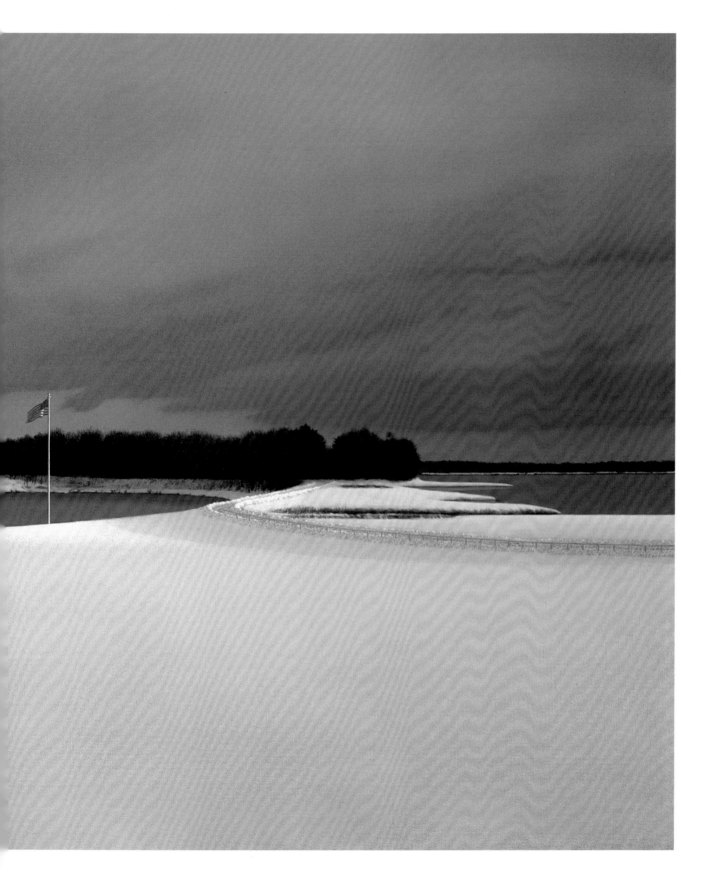

VIEW FROM BLANEY POINT, ca. 2001

CHRONOLOGY

1934 November 30: Thomas Robert Crotty is born in Boston to Donald Edward and Eleanor Wanda Crotty. He is the eldest of five children.

1936 In search of journalism work during the depression, his father moves the family to Charlottetown, Prince Edward Island.

1940 The family relocates to Summerside, where Thomas shows an early interest in art by drawing boats he sees in the Northumberland Straits.

1941 The family moves to rural Cartierville, outside of Montreal, where Thomas spends much of his free time exploring the woodlands.

1943 With his mother and siblings, he moves to Lakeburn, outside of Moncton, New Brunswick, while his father takes a position with United Press in New York.

1946 His father rejoins the family in Lakeburn and establishes a news service focusing on the Maritime Provinces, which is eventually taken over by shareholders.

1949 His father relocates his wife, two sons, and eldest daughter to Boston, leaving the two younger daughters in Moncton with their aunts.

1950 He begins attending Boston Technical High School and becomes actively involved in the art club.

Thomas Crotty, ca. 1937

Donald Edward Crotty, 1941

Eleanor Wanda Crotty, 1933

1951	Joins Boston Park Yacht Club's sailing program and meets friend and mentor Joe Lee. After winning the club's annual regatta in 1952, he becomes a sailing instructor at the club.
1952	His younger brother, Donald Jr., dies from injuries sustained in a bicycle accident. After dropping out of high school, Thomas begins a period of work at various businesses. He later buys a 26-foot Coast Guard Surfboat, converts it to a sailboat, and cruises to Maine.
1954	His father dies at age 44.
1958	Receives his High School Equivalency Certificate and begins attending Massachusetts College of Art in Boston.
1958	December 20: Marries Carolyn (Bunty) Wallace, a college student at Fisher Junior College in Boston.
1960	March 14: First son, Donald Edward, is born, and the new family moves to Cohasset, where Thomas lobsters in the mornings before classes and on the weekends.
1960	Fall: Finding himself at odds with Massachusetts College of Art's lack of technical instruction and emphasis on abstract expressionism, he leaves school and begins lobstering fulltime while continuing to draw and paint on his own.
1961	March 12: Second son, David Wallace, is born.
1962	Begins working full-time as a designer with Rust Craft Greeting Cards in Dedham, Massachusetts. One of his watercolors wins first prize at the Lowell Arts Festival, the first of many awards for his painting.
1963	Views an exhibition at the Fogg Art Museum entitled *Andrew Wyeth: Dry Brush and Pencil Drawings,* which he finds inspirational. It energizes his desire to become a professional artist.
1963– 1964	Moves his family to Maine in December, living temporarily in Windham before buying a home in Cape Elizabeth. He takes a position with Ad-Ventures Advertising in Portland as a designer and paste-up artist.
1965	March 22: First daughter, Johanna, is born.
1966	Purchases a farmhouse in Freeport, and in June, he and his wife open Frost Gully Gallery—Maine's first year-round art gallery—in the barn. Now free to focus on his painting full-time, he begins experimenting with acrylic paints, which become a standard medium in his work.

Thomas Crotty and Carolyn (Bunty) Wallace, December 20, 1958

Thomas Crotty's children in 1972 (clockwise: David, Donald, Melissa, and Johanna)

1967 August 2: Second daughter, Melissa, is born. Many of
Maine's prominent artists are joining Frost Gully Gallery,
which is now firmly established. Several of these artists,
whom he admires, begin having subtle influences on his
painting.

1968 With a young family to capture his attention, he begins
painting figurative works using his children as subjects.

1969 November: The solo exhibition *Thomas Crotty: Acrylics,
Watercolors, Drawings* is held at The Guild of Boston
Artists (11/1/69–11/20/69), which then travels to
Westbrook Junior College, Portland (12/1/69–12/20/69).

1970 September: A solo exhibition is held at Country Art Gallery
in Locust Valley, Long Island, New York (9/22/70–10/1/70).

1971 May: A solo exhibition is held at Treat Gallery, Bates
College, Lewiston, Maine (5/26/71–6/14/71).

1972 A second solo exhibition is held at the Country Art Gallery.

1973 February: An exclusive showing of paintings by Thomas
Crotty is held at the Hobe Sound Galleries, Hobe Sound,
Florida (2/12/73–2/27/73).

1973 June: The exhibition *Thomas Crotty: Watercolors and
Acrylics* opens at the Farnsworth Art Museum, Rockland,
Maine (6/3/73–7/1/73).

Thomas Crotty and Pauline (Polly) Halle,
January 28, 1981.

The Crotty family, ca. 1985 (clockwise: Thomas, Pauline, Johanna, Donald,
Melissa, Erin, and David)

1973	November: The solo exhibition *The Return to Realism: Thomas Crotty* is held at the Carl Van Vechten Gallery of Fine Arts, Fisk University, Nashville, Tennessee (11/11/73– 12/4/73).
1973	A year after his divorce from his wife Bunty, he moves the Frost Gully Gallery to Portland.
1977	Curates an exhibition entitled *The Art of Wood in Maine*, which is shown at the Bowdoin College Museum of Art in conjunction with the first Maine Arts Festival. He also begins to design and build a 35-foot sailboat, which is launched in 1981.
1980	Introduces oils to his paintings, which become the primary medium in his work through to the present.
1981	Marries second wife Pauline (Polly) Halle.
1982	January 8: His daughter, Erin Anne, is born.
1988	Stylistically his work broadens into panoramic land- and seascapes.
1989	Beginning with *Monocular Vision*, the inaugural exhibition at the new Simonds building of the Fitchburg Art Museum in Massachusetts, his work begins, and remains, to be highly sought after for inclusion in exhibitions throughout the United States.
1993	With his second wife, he buys a dilapidated bed and breakfast in Tenants Harbor, which they sell four years later after renovating.
1995	Completes the first in a series of nine works entitled *Drift in Beach.*
1995	September 20: First grandson, David Maaghul, is born.
1997	August 4: First granddaughter, Olivia, is born.
1998	His second marriage ends in divorce.
1999	July 21: Second grandson, Phillip, is born.
2000	After building an addition onto his home for new gallery and studio space, Frost Gully Gallery is moved back to its original Freeport location.
2000	March: The mini-retrospective *Tom Crotty: The Essential Maine: Landscape Paintings* is held at the Maine Coast Artists (now Center for Maine Contemporary Art), Rockport (3/25/00–5/6/00).
2002	July 8: Third grandson, Jack Chaput, is born.
2003	September 25: The solo exhibition *A Solitude of Space: The Paintings of Thomas Crotty* opens at the Portland Museum of Art, Maine.

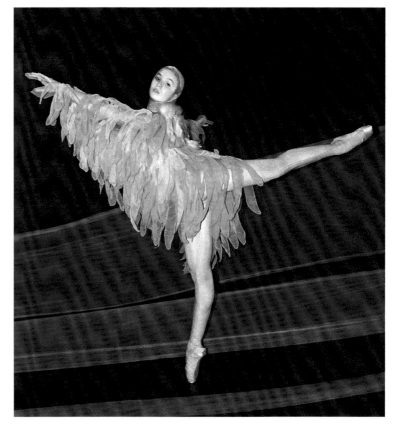

Erin Crotty rehearsing for the Portland Ballet Company's production of *Dreambirds,* 1998

SELECTED BIBLIOGRAPHY

"An Artful Summer." *Art and Antiques*, June 1990.

An Eye for Maine: Paintings from a Private Collection. Portland, Maine: Portland Museum of Art, 1994.

Barry, William David. *Celebrating Maine's Heritage and Tradition: The Casco Northern Bank Collection*. Portland, Maine: Frost Gully Gallery, 1994.

Beem, Edgar Allen. *Maine Art Now*. Gardiner, Maine: Dog Ear Press, 1990.

—————. 'Pellucid and Pearlescent: Why Painters Pursue the Quality of Light in Maine."*Habitat: Journal of the Maine Audubon Society*, December 1991.

—————. "The Visual Arts: Real and Surreal Intuitions at Frost Gully." *Maine Times*, 26 October 1990.

Beetle, Jean. "Tom Crotty's Art of the Particular." *The Brunswick News*, 3 September 1970.

Betts, Edward H. *Creative Landscape Painting*. New York: Watson-Guptill, 1978.

Brandes, Kathleen M. *Maine Handbook*. Chico, Calif.: Moon Publications, 1998.

Carried Away: The Joy of Collecting Art in Maine: Selections from the Joanna D. and Henry L. McCorkle Collection. Lewiston, Maine: Bates College Museum of Art, 1999.

Cole, John N. "Tom Crotty's 25 Years of Gallerying." *Portland Magazine*, October 1991.

Crotty, Thomas. "Exhibit: The Combination Increases the Impact." *Maine Times*, 23 April 1976.

—————. "Maine: A Land for Artists." *Art Gallery Magazine*, August–September, 1984.

—————. "The Maine Attraction." *Maine Sunday Telegram*, 2 August 1992.

—————. "Maine's Artists Wandering in a Wilderness." *Maine Sunday Telegram*, 9 August 1992.

—————. "Taking Our Artists Seriously." *Maine Sunday Telegram*, 16 August 1992.

Culver, Michael. *Realism in 20th Century American Painting*. Ogunquit, Maine: Ogunquit Museum of American Art, 1997.

Dane, Lawrence. "A Double Dose of Maine Talent." *Palm Beach Post*, 15 February 1973.

Dorsey, John. "Landscapes Portray an America Still Unspoiled." *Baltimore Sun*, 21 November 1994.

Driscoll, John. *The Artist and the American Landscape*. Cobb, Calif.: First Glance Books, 1998.

Expressions from Maine 1976. Hobe Sound, Fla.: Hobe Sound Galleries, 1976.

"Gallery Preview." *Boston Arts*. 2, no. 11, (1969).

Geisman, Maxwell, ed. *The Whitman Reader*. New York: Pocket Books, 1955.

Gussow, Alan. *The Artist as Native: Reinventing Regionalism*. Rohnert Park, Calif.: Pomegranate Art Books, 1993.

—————. *Rediscovering the Landscape of the Americas*. Santa Fe, New Mexico: Gerald Peters Gallery, 1996.

Isaacson, Philip. "Standing Up for Maine Art." *Maine Sunday Telegram*, 8 December 1991.

Koslow, Francine. *Henry David Thoreau as a Source for Artistic Inspiration*. Lincoln, Mass.: DeCordova Museum and Sculpture Park, 1984.

Lafo, Rachel, Nick Capasso, and Jennifer Uhrhane, eds. *Painting in Boston: 1950–2000*. Lincoln, Mass.: DeCordova Museum and Sculpture Park, 2002.

Le Brun, Carol. "The Many Moods of Thomas Crotty." *Boston Sunday Herald Traveler*, 9 November 1967.

Little, Carl. "Different Beats." *Down East*, 9 November 1995.

—————. "Eye on the Coast: Portland Based Artist Tom Crotty." *Maine Boats and Harbors*, 2, no. 1 (1998).

Little, Carl, and Arnold Skolnick. *Art of the Maine Islands*. Camden, Maine: Down East Books, 1997.

—————. *The Art of Maine in Winter*. Camden, Maine: Down East Books, 2002.

—————. *Paintings of Maine*. Camden, Maine: Down East Books, 1998.

—————. *Paintings of New England*. Camden, Maine: Down East Books, 1996.

Magiera, Frank. "Monocular Exhibition Displays Regional Depth with Realism." *Fitchburg Telegram and Gazette*, 11 August 1989.

Maine: 100 Artists of the 20th Century. Waterville, Maine: Colby College Museum of Art, 1964.

Maine, the Spirit of America. New York: Harry N. Abrams, 2000.

McCord, David. *Andrew Wyeth*. Boston: Museum of Fine Arts, Boston, 1970.

McWilliams, Margot Brown. "Changing Landscapes at the Portland Museum of Art." *Casco Bay Weekly*, 21 January 1993.

Meisel, Louis K. *Photo-Realism*. New York: Harry N. Abrams, 1980.

Mellon, Gertrud A., and Elizabeth F. Wilder, eds. *Maine and Its Role in American Art, 1740–1963*. New York: Viking, 1963.

Merrill, Meadow. "Thomas Crotty's Eye for Winter." *Down East*, February 2000.

Preston, Malcolm. "Super-Real Rural Scene for Tom Crotty." *Newsday*, 25 September 1972.

The Return to Realism: Thomas Crotty. Nashville, Tenn.: Carl Van Vechten Gallery of Fine Arts, Fisk University, 1973.

Thomas Crotty. Lewiston, Maine: Treat Art Gallery, Bates College, 1971.

Thomas Crotty. Locust Valley, Long Island: Country Art Gallery, 1970.

Thomas Crotty: Acrylics, Watercolors, Drawings. Boston: The Guild of Boston Artists, 1969.

Thomas Crotty: Watercolors, Acrylics. Hobe Sound, Fla.: Hobe Sound Galleries, 1973.

Thomas Crotty: Watercolors and Acrylics. Rockland, Maine: William A. Farnsworth Library and Art Museum, 1973.

Wilson, Emily. "Frost Gully Returns to Freeport." *Times Record*, 23 March 2000.

Thomas Crotty, April 2003

SOLO EXHIBITIONS

The Guild of Boston Artists, Massachusetts, 1969

Westbrook Junior College, Portland, Maine, 1969

Country Art Gallery, Locust Valley (Long Island), New York, 1970 and 1972

Bates College, Lewiston, Maine, 1971

Farnsworth Art Museum, Rockland, Maine, 1973

Hobe Sound Galleries, Hobe Sound, Florida, 1973

Fisk University, Nashville, Tennessee, 1973

Maine Coast Artists (now Center for Maine Contemporary Art), Rockport, Maine, 2000

Portland Museum of Art, Maine, 2003

SELECTED GROUP EXHIBITIONS

Annual Exhibitions of Contemporary New England Artists, Edward J. Mitton Center, Boston, 1962, 1966 through 1970

Eastern States Exposition, Museum of Fine Arts, Springfield, Massachusetts, 1965 and 1966

American Watercolor Society Annuals, 1966, 1967, 1968, 1970, and 1971

University of Maine Museum of Art, Orono, 1968, 1969, and 1970

Four Maine Artists, Farnsworth Art Museum, Rockland, Maine, 1969

Maine Art Gallery, Wiscasset, 1969 and 1970

Boston Watercolor Society Annuals, 1967, 1968, and 1969

Phillips Exeter Academy, Exeter, New Hampshire, 1976

National Academy of Design, New York, 1970

Temple Beth El Annual Exhibitions, Portland, Maine, 1966 through 1971

Collectors I, Portland Museum of Art, Maine, 1970

The Guild of Boston Artists, 1967 through 1971

Landscape I, DeCordova Museum and Sculpture Park, Lincoln, Massachusetts, 1970

Maine Coast Artists, Rockport, Maine, 1970

Maine 75, Bowdoin College, Brunswick, Maine, 1975

76 Maine Artists, The Bicentennial Exhibition, Maine State Museum, Augusta,1976

Expressions From Maine, 1976 (traveled to Pepperdine University, Malibu, California; Hamline University, St. Paul, Minnesota; Headley Museum, Lexington, Kentucky; Agnes Scott College, Decatur, Georgia; and Hobe Sound Galleries, Hobe Sound, Florida), 1976

Barn Gallery Invitational, Ogunquit, Maine, 1985

Monocular Vision: New England Realist Artists, Fitchburg Art Museum, Massachusetts, 1989

On the Edge: Forty Years of Maine Painting 1952–1992, Maine Coast Artists, Rockport, Maine (traveled to the Portland Museum of Art, Maine), 1992

The Maine Connection, Sherry French Gallery, New York, 1993

Mainescapes, Ogunquit Museum of American Art, Maine, 1993

The Artist as Native: Reinventing Regionalism, Babcock Galleries, New York, 1993 (traveled to Middlebury College Museum of Art, Vermont, 1993; Albany Institute of History and Art, New York, 1994; Owensboro Museum of Fine Art, Kentucky, 1994; Westmoreland Museum of American Art, Greensburg, Pennsylvania, 1994; and The Maryland Institute, College of Art, Baltimore, 1994)

An Eye for Maine: Paintings from a Private Collection, Portland Museum of Art, Maine, 1994–1995

Maine Watercolors, Maine Art Gallery, Wiscasset, 1994

Nightlight, Barn Gallery, Ogunquit, Maine, 1995

On the Waterfront, Maine Coast Artists, Rockport, Maine, 1995

Rediscovering the Landscape of the Americas, Gerald Peters Gallery, Santa Fe, New Mexico, 1996 (traveled to Art Museum of South Texas, Corpus Christi, 1996; Western Gallery, Western Washington University, Bellingham, Washington, 1996; Memorial Art Gallery of the University of Rochester, New York, 1997; and the Gibbes Museum of Art, Charleston, South Carolina, 1997)

Realism in 20th Century American Painting, Ogunquit Museum of American Art, Maine, 1997

Carried Away: The Joy of Collecting Art in Maine, Bates College Museum of Art, Lewiston, Maine, 1999

Past–Present–Future: 50th Anniversary Invitational Exhibition, Center for Maine Contemporary Art, Rockport, Maine, 2002

AWARDS

Lowell Arts Festival, First Prize, 1962

Central Maine Art Gallery, First Prize, 1965

Eastern States Exposition, West Springfield, Massachusetts, First Prize, Watercolor Division, 1965

37th Annual Exhibition of New England Artists, First Prize, 1966

37th Annual Exhibition of New England Artists, Juror's Award, 1966

38th Annual Exhibition of New England Artists, First Prize, 1967

Boston Watercolor Society, First Honorable Mention, 1968

39th Annual Exhibition of New England Artists, Second Prize, 1968

American Watercolor Society, Ted Kautsky Memorial Award, 1968

40th Annual Exhibition of New England Artists, First Prize, 1969

40th Annual Exhibition of New England Artists, Juror's Award, 1969

American Watercolor Society, Arches Paper Award, 1971

MEMBERSHIPS

Boston Watercolor Society

American Watercolor Society

The Guild of Boston Artists

Advisory Committee, *Maine 75,* Bowdoin College, Brunswick, Maine, 1975

Board of Directors, Maine Arts Festival

Curator, *The Art of Wood in Maine*, Walker Art Museum, Bowdoin College, Brunswick, Maine, 1977

Advisory Board, Joan Whitney Payson Gallery, Westbrook Junior College, Portland, Maine

Architectural Planning Committee, Portland Museum of Art, Maine

Scholarship Committee, Skowhegan School of Painting and Sculpture, Maine

Founder and first President, Portland Society of Galleries and Museums, Maine

Fellow, Portland Museum of Art, Maine

Council of Advisors, Art Gallery at University of New England, Portland, Maine

Owner and Director, Frost Gully Gallery since 1966

PUBLIC AND PRIVATE COLLECTIONS

Farnsworth Art Museum, Rockland, Maine

Portland Museum of Art, Maine

University of New England, Biddeford, Maine

University of Maine Museum of Art, Orono

UnumProvident, Portland, Maine

Pierce Atwood, Portland, Maine

Perkins, Thompson, Hinckley & Keddy, Portland, Maine

KeyBank, Portland, Maine

Peoples Heritage Bank, Portland, Maine

South Shore National Bank, Quincy, Massachusetts

Shawmut Bank, Boston, Massachusetts

First–Manufacturers National Bank of Lewiston and Auburn, Maine

Cole Haan, Yarmouth, Maine

Central Maine General Hospital, Lewiston

Many private collections across the United States

Thomas Crotty's original Freeport studio, where he worked from 1967 to 2000

LIST OF ILLUSTRATED WORKS

Unless otherwise noted, all works are by
Thomas Crotty (United States, born 1934).
Dimensions are in inches, height preceding width.

APPLE TREE IN WINTER, ca. 1969
Watercolor on paper, 23 x 29
Collection of Mary Lou and Ralph Lancaster
27

AUBURN CHURCH, ca. 1986
Oil on masonite, 16 x 24
Collection of Cole Haan
61

BACKYARD WINTER SOUTH, ca. 1988
Oil on masonite, 18 x 36
Private collection
46–47

BARRED ISLANDS, ca. 1993
Oil on canvas, 24 x 48
Collection of the Becker Family
56–57

BARRELS BY THE BARN, 1967
(also entitled **TWO BLACK BARRELS**)
Watercolor on paper, 12 ⁵/₈ x 20 ¹/₁₆
Portland Museum of Art, Maine.
Gift of Owen W. and Anna H. Wells, 2001.83.8
31

BASIN COVE #2, ca. 1989
Oil on masonite, 21 ¹/₂ x 35 ¹/₂
Collection of Dr. and Mrs. Robert P. Timothy
44–45

BASIN COVE, DUSK, ca. 1989
Oil on canvas, 30 x 60
Collection of Mr. and Mrs. John B. MacDonald
92–93

BREAKING, ca. 1975
Acrylic on canvas, 28 x 28
Collection of Larry and Jean Pugh
12

BROAD SOUND, ca. 1988
Oil on canvas, 24 x 36
Collection of William B. and Deborah Reynolds
76

BUNGANUC ROAD, ca. 1992
Oil on canvas, 24 x 40
Collection of Owen W. and Anna H. Wells
74–75

CHANEY'S, 1969
Watercolor on paper, 9 ¹/₂ x 19
Collection of Andrew and Betsy Wyeth
41

CHANEY'S II, ca. 1991
Oil on canvas, 24 x 40
Collection of Barbara and Dino Giamatti
51

CHARLES S. PAYSON, 1981
Watercolor on paper, 16 x 24
Location unknown
52

CUSHING IN WINTER, ca. 1990
Oil on canvas, 24 x 36
Collection of Mrs. Margaret Taragowski
70 and jacket

DAVID, ca. 1975
Watercolor on paper, 20 ³/₄ x 13 ¹/₂
Frye Island Collection,
Lent anonymously to the
Portland Museum of Art, Maine
39

DOLPHIN MARINA, ca. 1986
Oil on masonite, 26 x 34
Collection of Pierce Atwood
37

DOLPHIN MARINA AND EAGLE ISLAND, ca. 1985
Oil on canvas, 16 x 24
Collection of Mr. and Mrs. John B. MacDonald
50

DOLPHIN MARINA IN WINTER, ca. 1984
Oil on masonite, 22 x 48
Collection of KeyBank
58–59

DONALD, 1969
Acrylic on masonite, 26 x 32 ¹/₂
Collection of the Farnsworth Art Museum,
purchased from the artist through the
Katherine Haines Fund, 1969
38

DONALD AND DAVID, 1969
Watercolor on paper, 29 x 23
Collection of the University of New England,
Gift of John Whitney Payson
29

DRIFT IN BEACH, ca. 1995
Oil on canvas, 30 x 72
Collection of William F. Farley
94–95

DRIFT IN BEACH II, ca. 1996
Oil on panel, 12 x 12
Private collection
97

DRIFT IN BEACH IV, ca. 1996
Oil on canvas, 28 x 72
Collection of Pierce Atwood
98–99

DRIFT IN BEACH VII, ca. 1996
Oil on canvas, 48 x 48
Private collection
96

DUSK, NEW VINEYARD, ca. 1996
Oil on canvas, 12 x 12
Private collection
18

DUSK—WOLFE'S NECK, ca. 1999
Oil on canvas, 18 x 24
Collection of Jennifer and Jefferson Kimball
89

DYER ROAD, POWNAL, ca. 2000
Oil on canvas, 12 x 24
Collection of Mr. and Mrs. C. David O'Brien
10–11

FROST GULLY, NEW SNOW ca. 1981
(also entitled FROST GULLY—JANUARY)
Oil on canvas, 24 x 48
Collection of Mr. and Mrs. John B. MacDonald
71

FROST GULLY WITH BILLBOARDS, ca. 1980
Oil on masonite, 23 $\frac{1}{2}$ x 48
Private collection
2–3

INDIAN POINT—LOW TIDE, ca. 1990
Oil on canvas, 36 x 60
Private collection
69

INDIAN POINT—MARCH, ca. 1992
Oil on canvas, 48 x 60
Private collection
105

JERICHO BAY, 1992
Oil on masonite, 8 x 11 $\frac{7}{8}$
Private collection
23

LAURA B, ca. 2000
Oil on canvas, 10 x 20
Private collection
120

LEDGES AT BAILEY ISLAND, 2002
Oil on canvas, 40 x 40
Collection of the artist
102

MARSHALL POINT PROMENADE, ca. 1985
(also entitled MARSHALL POINT)
Oil on masonite, 21 $\frac{1}{2}$ x 29 $\frac{1}{2}$
Collection of Perkins, Thompson, Hinckley & Keddy, PA
60

MERIDIAN, 1967
Watercolor on paper, 16 $\frac{1}{2}$ x 39 $\frac{1}{2}$
Private collection
35

MIGIS LODGE, ca. 1986
Oil on masonite, 30 x 60
Collection of Tim and Joan Porta
78–79

MONHEGAN, ca. 1993
Oil on panel, 10 x 12
Collection of Helen and Roger Stoddard
63

MONHEGAN GEAR, ca. 1998
Oil on panel, 10 x 10
Collection of Jan and Scott Searway
104

MUSSELS, ca. 1998
Oil on canvas, 10 x 10
Collection of Mr. and Mrs. John B. MacDonald
33

NEWPORT 1977, 1996
Oil on canvas, 24 x 30
Collection of Owen W. and Anna H. Wells
54

NEWSPAPERS, 1969
Watercolor on paper, 16 x 23
Private collection
30

VIEW FROM BLANEY POINT, ca. 2001
Oil on canvas, 26 x 52
Collection of Larry and Jean Pugh
106–107

VIEW WITH JAQUISH ISLAND, 2003
Oil on panel, 24 x 32
Private collection
67

VINALHAVEN, ca. 1995
Oil on canvas, 60 x 60
Private collection
64

VINALHAVEN SUNSET, ca. 2001
Oil on panel, 10 x 20
Collection of Owen W. and Anna H. Wells
90

WINTER ORCHARD, ca. 1982
(also entitled FEBRUARY 19TH)
Graphite and watercolor on wove paper,
22 $^5/_8$ x 31 $^1/_4$
Portland Museum of Art, Maine.
Gift of the R.F. Haffenreffer, IV and
Mallory K. Marshall Family, 1991.55.7
40

WOLFE'S NECK II, 1992
Oil on canvas, 44 $^3/_4$ x 44 $^7/_8$
Portland Museum of Art, Maine.
Anonymous gift, 1992.17.1
87

WOLFE'S NECK PASTURE, ca. 1973
Acrylic on canvas, 24 x 44
Private collection
48–49

Andrew Wyeth
(United States, born 1917)
SPRUCE BOUGH, 1969
Watercolor on paper, 29 $^1/_4$ x 29 $^3/_8$
Private collection
© Andrew Wyeth
43

PHOTOGRAPHIC ACKNOWLEDGMENTS

(Unless otherwise noted, all photographs are provided courtesy of the lenders.)

jacket, 8, 10–11, 12, 16, 24, 26, 27, 29a, 30, 31a, 32, 35, 37, 41, 42, 44–45, 46–47, 48–49, 51, 52, 54a, 56–57, 62, 63, 64, 67, 68, 69, 70, 71, 72–73, 74–75, 76, 80–81, 82–83, 84–85, 86, 88, 89, 90, 94–95, 96, 97, 98–99, 100, 102, 104, 105, 120: Courtesy of Frost Gully Gallery, Freeport, Maine

1, 2–3, 18, 22, 23, 25, 29b, 31b, 39, 40, 58–59, 60, 61, 78–79, 87, 91, 106–107: Photographs by Melville D. McLean

4 (frontispiece) and 115: Photographs by David Etnier.

13, 17, 19, 20, 21, 28, 34, 36, 53, 54b, 55, 65, 77, 108, 109, 110: Courtesy of Thomas R. Crotty.

66: Photographs by Francine Koslow Miller.

101 and 113: Photographs by Janvier Rollande.

111: Photograph by Stuart Nudelman

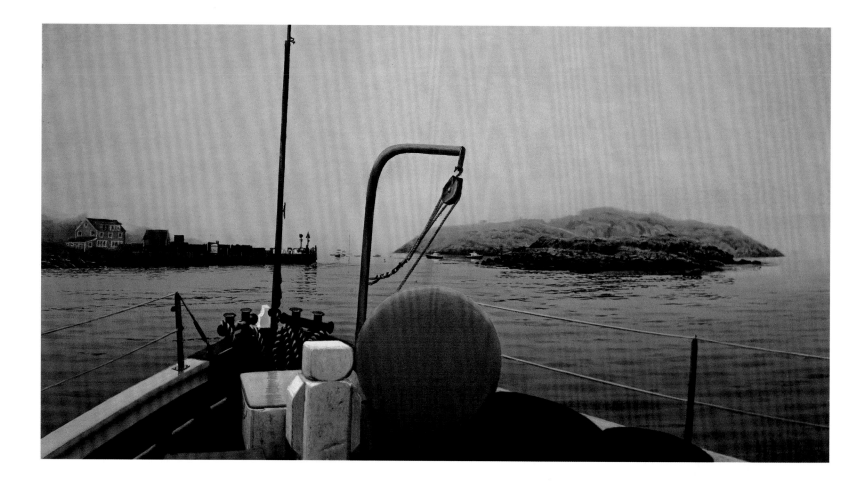

LAURA B, ca. 2000